ABERYSTWYTH
THROUGH TIME
William Troughton

AMBERLEY

To Lorena, Ioan & Eluned for their help and patience.

First published 2010

Amberley Publishing
Cirencester Road, Chalford,
Stroud, Gloucestershire, GL6 8PE

www.amberley-books.com

Copyright © William Troughton, 2010

The right of William Troughton to be identified
as the Author of this work has been asserted in
accordance with the Copyrights, Designs and
Patents Act 1988.

ISBN 978 1 84868 747 9

British Library Cataloguing in Publication Data.
A catalogue record for this book is available from
the British Library.

Typeset in 9.5pt on 12pt Celeste.
Typesetting by Amberley Publishing.
Printed in the UK.

Introduction

According to the 2009 International Student Barometer Aberystwyth rated first out of 123 academic institutions as being a 'good place to be.' For those of us who live here, well let's face it, we knew that already. Aberystwyth is many things. As well as being the cultural capital of Wales it is a tourist resort, market and university town. It is a place that has always attracted a mixed bunch, which is why H. G. Wells, Amy Johnson, Richard Burton, Led Zeppelin and the Rolling Stones all get a mention here.

This book is not a history of the town but is designed as a tour in a broadly clockwise direction, starting at the castle. From here the trail passes through Penmaesglas Road and South Road to the harbour, along the length of the promenade (not forgetting to kick the bar) to Cliff Terrace and Brynymor Road. From the golf course we stroll along Queens Road and up to the National Library of Wales. After a look inside it's down to Llanbadarn Fawr, through Penparcau and Trefechan to the centre of town. Seven hundred years ago a defensive wall protected Aberystwyth. Despite its disappearance centuries ago this wall is responsible for the present day street pattern. Our tour though follows the one way system for a while, so from the town clock the trail takes us down Great Darkgate Street, along Chalybeate Street, into Alexandra Road and along Terrace Road to the junction with North Parade. From North Parade it is a short hop to the railway station before heading back through town to St Michael's Church next to where we started.

The intention of the book is to juxtapose old and new photographs, creating a sense of what the town was like and how it has changed. By interweaving Aberystwyth trivia and historical information it is hoped that even seasoned scholars of the town's history will learn something new. Most of the older pictures selected are from about a hundred years ago. Nearly every page shows the differences that a century has made to the town. Gone are the milliners, boatmen, dressmakers, watchmakers and curriers. Now, cafés, charity shops, nail bars, double yellow lines and mobile 'phones dominate the streets. A hundred years ago the only Blackberries were the ones you picked!

The population according to the 2001 census was 15,935. For a town of its size it exhibits an unrivalled degree of cosmopolitanism. For example the town boasts restaurants offering Chinese, Greek, Indian, Italian, Japanese, Spanish, Thai, Turkish and of course Welsh cuisine. It also has six bookshops, a sure sign of civilisation.

Aberystwyth still has many wonderful Victorian buildings, including a number of fine chapels. In fact such was the enthusiasm for chapel building that in 1891 when Aberystwyth had a population of 6,725 the town's ten largest chapels alone had a seating capacity of 6,194. Presumably the other 531 inhabitants were catered for by the established and catholic churches!

Sadly many of Aberystwyth's other Victorian buildings, including the Old College, face an uncertain future, while others, such as the Drill Hall, face the threat of demolition along with perfectly good houses in favour of another ugly red brick retail park with draconian parking restrictions.

Aberystwyth has weathered many storms, both meteorological and metaphoric. No doubt it will continue to adapt, thrive and prosper in its roles as tourist resort, market and university town. So, is Aberystwyth really a good place to be? Well, no – it's far and away *the* best place to be.

W. Troughton
2010

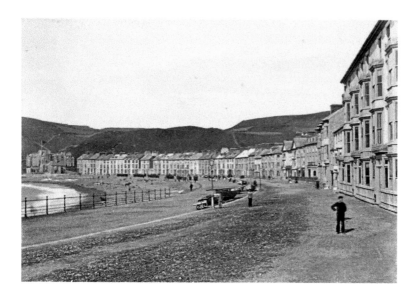

Aberystwyth Promenade, c. 1865
C. S. Allen was a Tenby photographer who saw the potential for selling photographs of the town to visitors after the railway arrived. The photograph possesses a tranquillity, but also an air of anticipation, about it, as though the town seems poised for the trainloads of visitors about to descend.

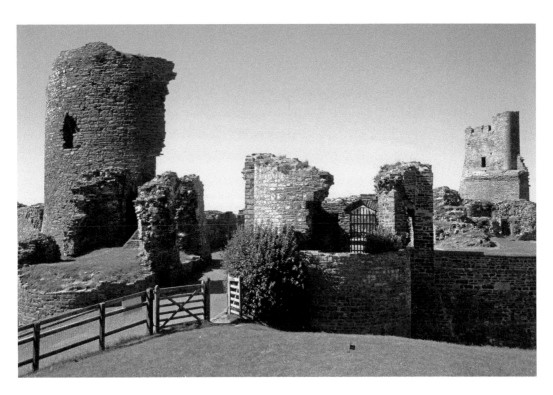

Castle Ruins, Aberystwyth *c.* 1905
Aberystwyth Castle was built over a twelve year period starting in 1277. It was captured in 1282, 1404 (by Owain Glyndwr), 1408, and 1646. It withstood sieges in 1282 and 1294 and was largely destroyed in 1649. The two ruined towers on the left once guarded the main entrance, that on the extreme right another smaller entrance.

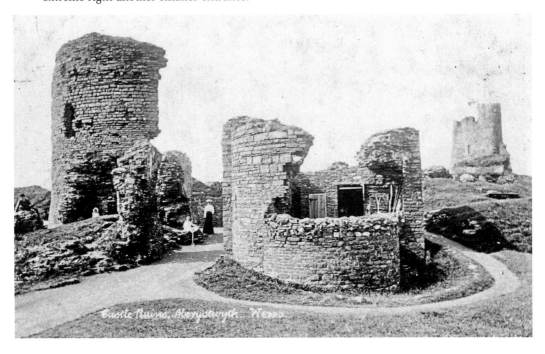

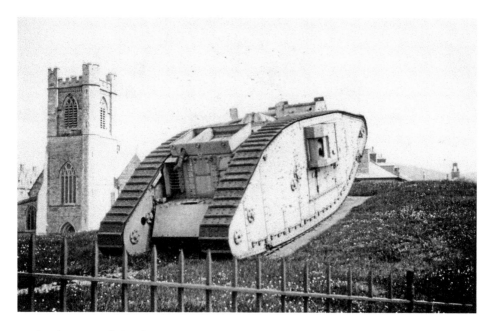

Tank, Aberystwyth Castle, 1921

Between August 1914 and July 1919 the inhabitants of Aberystwyth subscribed £2,614,990 to National War Savings. In January 1920 in recognition of this feat a 26-ton tank was presented to the town and placed on what was once the Barbican of the castle. The *Cambrian News* reassured its readers that certain parts of the machinery were removed by the crew before their departure, presumably including the six Lewis guns with which the tank was once armed. The effects of the salty coastal air led to its eventual removal. For reasons unknown there was also a German field gun outside the Edward Davies Laboratories for much of the early 1920s.

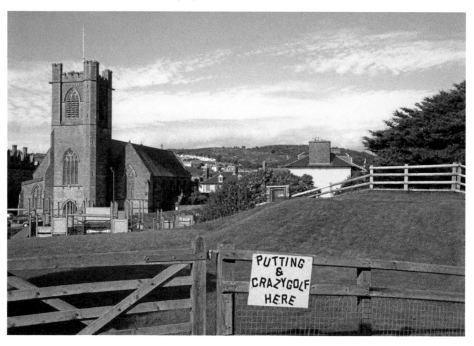

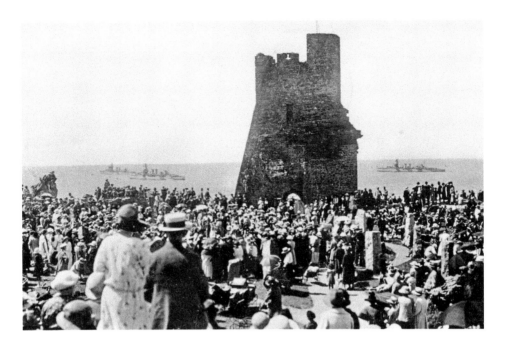

The Castle, Aberystwyth, 1925 & 1991

In the top view the crowd has gathered to watch the Royal Navy 12th destroyer division - HMS *Valhalla, Westcott, Wolfhound* and *Wessex* in June 1925. During the Second World War HMS *Wessex* was sunk in the evacuation of Dunkirk whilst Wolfhound and Westcott served as convoy escorts. The gorsedd stones visible amongst the crowd were erected for the proclamation ceremony for the 1916 National Eisteddfod held in the town. Equally popular was the proclamation ceremony for the 1992 National Eisteddfod. The gorsedd in their white, blue and green robes are much in evidence.

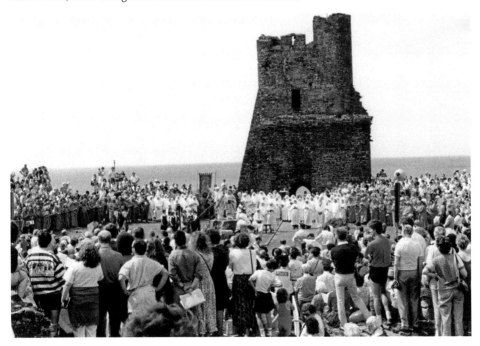

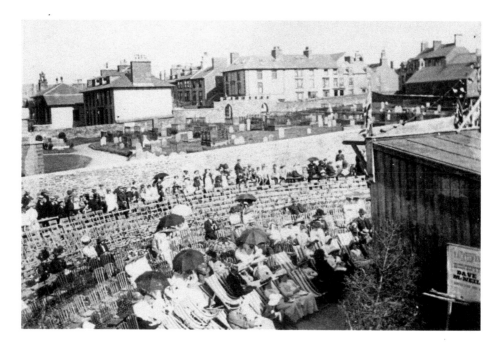

Pavilion, *c.* 1912

Tom Johnson's Yachtsmen were one of the most popular troupes to entertain in Aberystwyth. Between 1910 and 1914 they performed each summer in this pavilion below the Castle. Their act included such songs as *The Rollicking Rajah, My Little Lovin' Sugar Babe* and *Everyone's doing it at the Seaside*. Beyond the chairs can be seen the cemetery, long since tidied up to provide a play area and gardens. The tall building in the top centre of the photograph was once the Brynawel Temperance Hotel, hit by lightning in 1935. The children's playground opened in 1977, a gift from the local Round Table.

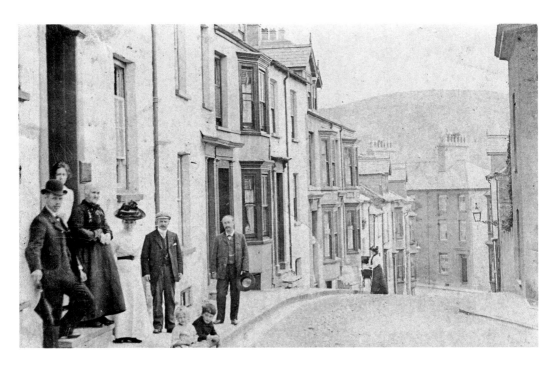

Penmaesglas Road, c. 1905

This is one of numerous streets near the harbour which has long associations with the town's maritime past. In all these streets many houses were named after ships or foreign destinations, names which despite their historical connotations continue to disappear. In 1891 Penmaesglas Road still had two boatmen, two ship's carpenters, a boat builder, a mariner and a master mariner residing there.

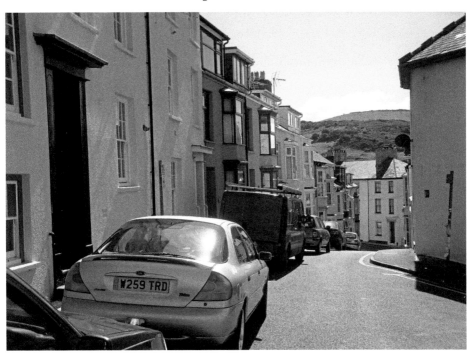

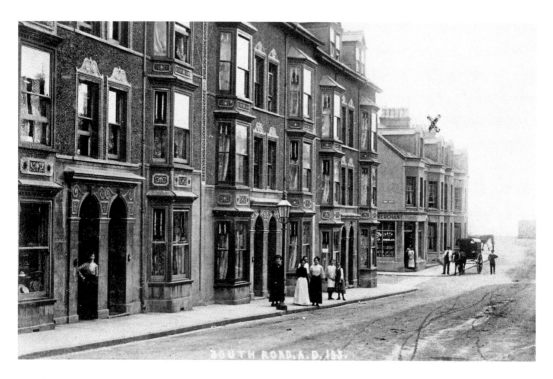

South Road, c. 1905

When the top view was taken c. 1905 South Road had recently replaced Shipbuilders Row as the street name and the houses on the left were all newly built. The house on the extreme left has hats on display in the window and is probably the home of Miss Griffiths, a milliner and dressmaker. Many of the other houses offered apartments to visitors. Today most of the houses in this row are student houses and the corner shop in the distance has long gone.

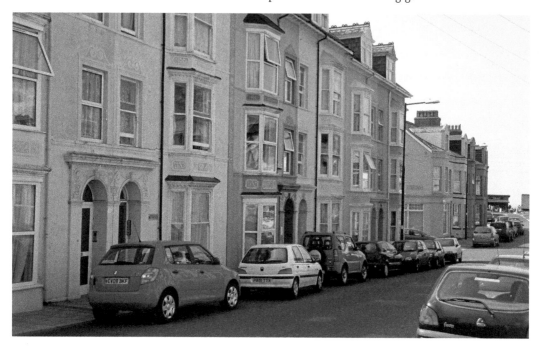

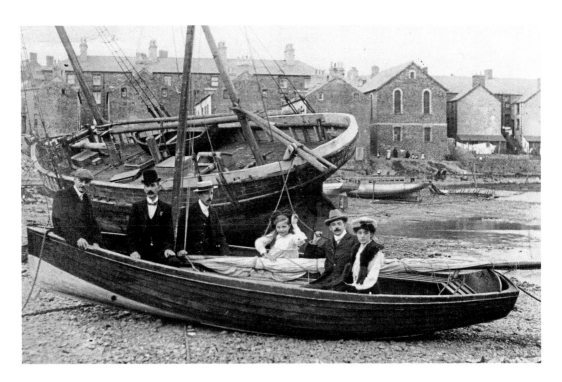

Porpoise, c. 1910
In the top photograph the would-be boating party are in the shadow of *Porpoise,* a 24-ton fishing boat built in Liverpool in 1837. In the bottom photograph *Beverley Rose,* a 1960 wooden Yorkshire Coble rides patiently at her mooring. The chapel building visible in both pictures was built as Tanycae Sunday School in 1875 and now houses Elim Pentecostal Church. This part of the harbour, known as Y Geulan, was used for shipbuilding for most of the nineteenth century.

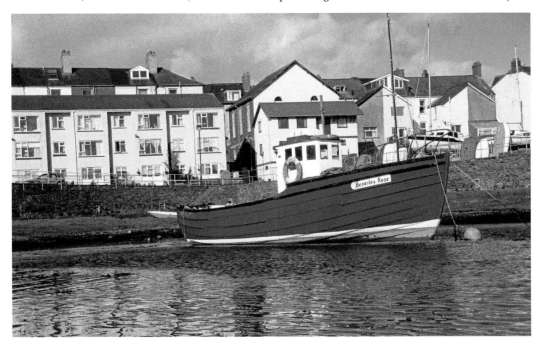

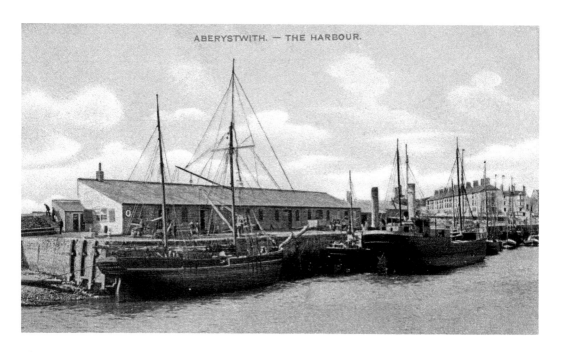

Aberystwyth – the Harbour, 1905

A crowded quayside in November 1905. On the left is the *William & Mary* from Bridgewater who arrived with building supplies, nestled against the quay is the *Countess of Lisburne* and outside her is the steamer *Mayflower* of Cardigan, sheltering from a recent storm. No cargo vessel has used the harbour since 1987 and the quayside is now used by a number of local fishing boats such as *Quaker* and *Pen Dinas*, seen in the bottom view. This part of the quay is also home to the town's highly successful rowing club.

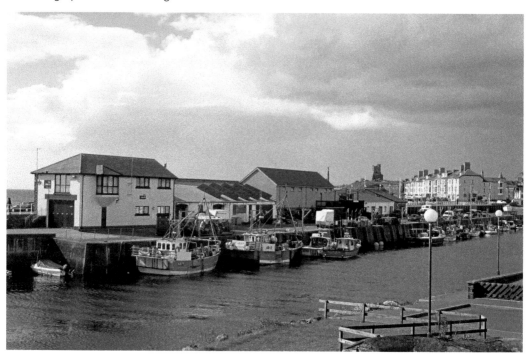

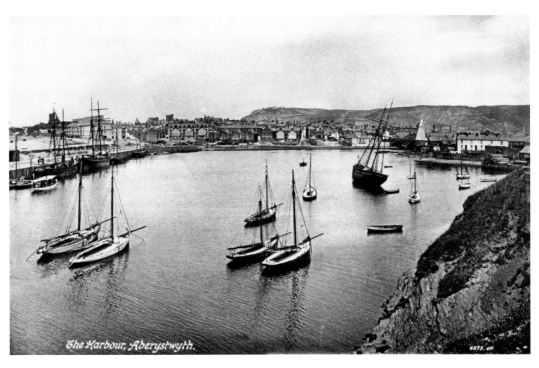

The Harbour, Aberystwyth, *c.* 1915

Some of the last vestiges of Aberystwyth's coastal trade are visible in the top view. Bulk cargoes such as timber, fertiliser and coal continued to arrive by sea, often in sailing vessels, until well into the twentieth century.

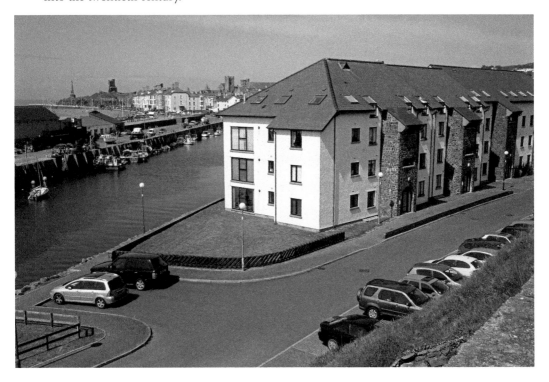

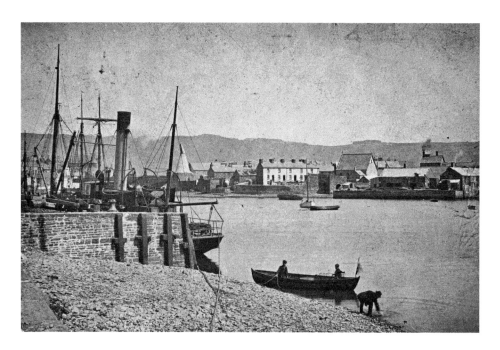

Steamer at the Quayside, *c.* 1905

The whitewashed cottages in the centre of the picture were known as Harbour Terrace, whilst the building to their right was Trefechan Sunday School. The steamer at the quayside is *Countess of Lisburne*, owned by a local steamship company. She traded regularly with Liverpool and other ports in North Wales before being sold in 1908.

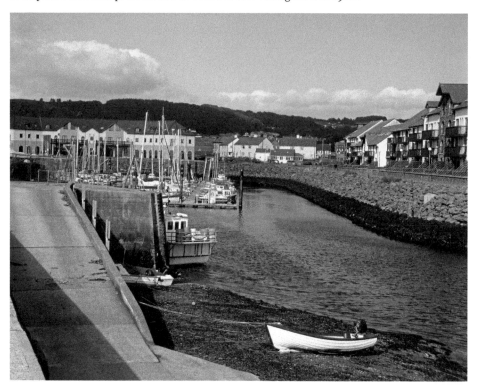

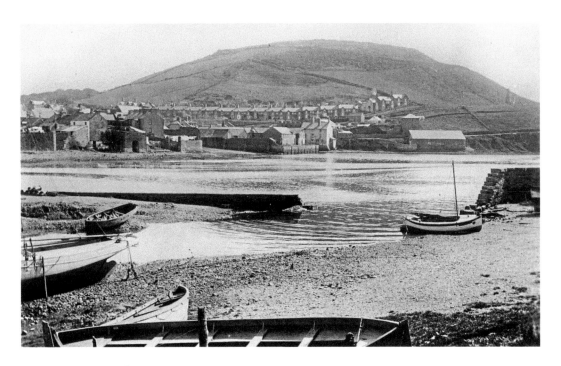

The Inner Harbour, c. 1930

By 1930 the harbour was regarded as something of a white elephant as Aberystwyth's sea trade continued to decline. In the top view only a small number of pleasure craft are visible and no commercial activity is discernable. The bottom view shows how much development has taken place in recent years on the Trefechan side of the harbour and how the nature of pleasure boating has changed.

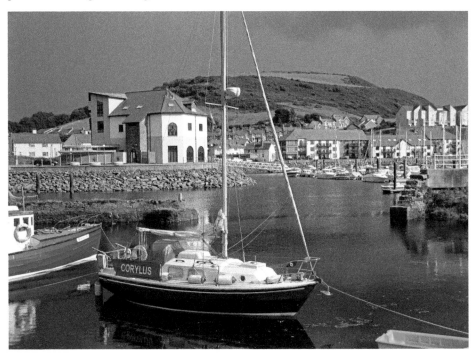

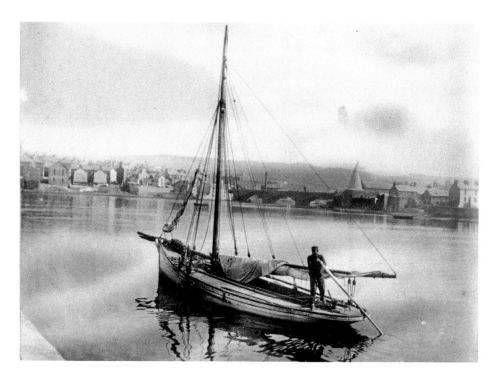

The Solitary Boatman, *c.* 1925

The extent to which the harbour had fallen into disuse is well illustrated in the top photograph where no other craft is visible other than the Morecambe Bay Nobby being manoeuvred up towards the inner harbour. The conical structure in the background is the malt drying kiln built by local brewer David Roberts. It still stands but is now obscured behind newer buildings.

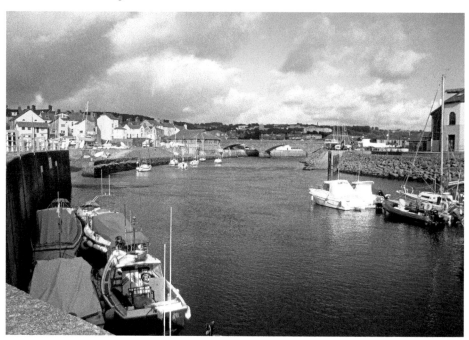

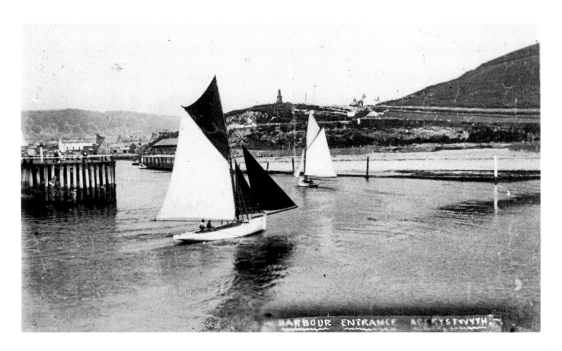

Harbour Entrance, Aberystwyth, *c.* 1910
The most obvious difference between these two views is the Plas Morolwg development on the skyline in the centre of the photograph. Also visible are the flats on St Davids Quay and Y Lanfa. In the top view the series of poles on the shoreline were each topped with a pulley. Used in conjunction with a capstan they were used to help larger vessels negotiate the right angle turn into the harbour. Ro-fawr, *c.* 1928.

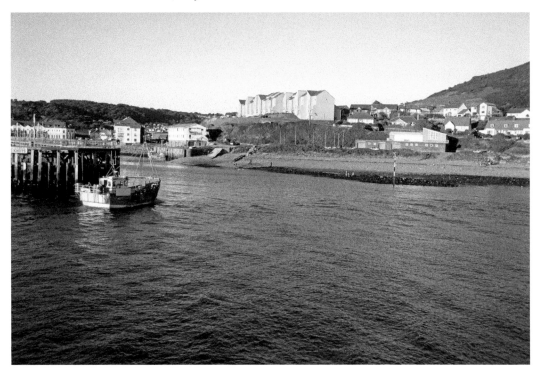

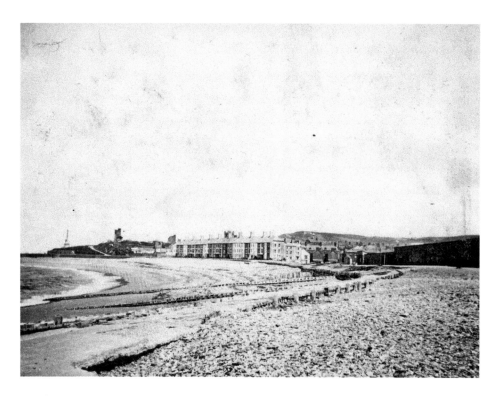

South Prom, *c.* 1925

The last part of the promenade to be built was that from South Marine Terrace to the harbour, on an area of beach known as Y Ro-fawr. This was built between 1930-1931 at a cost of £12,000 and provided much needed employment for over fifty men as well as extra protection from winter storms for boats in the harbour. In times past wooden groynes were sunk into the beach to try and stabilise the shingle. These can be seen on the foreshore in the top picture.

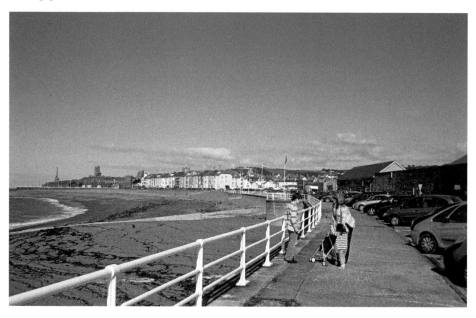

South Marine Terrace, Aberystwyth, *c.* 1925

South Marine Terrace was built on the site of a timber merchants yard. Today these handsome houses are a mixture of family homes, bed and breakfast establishments and flats. The war memorial on the left of the picture was erected in 1923 to honour those killed in the First World War. In the top photograph it is partly obscured by the lifeguards' hut. Since 2009 lifeguards at Aberystwyth have been provided by the RNLI.

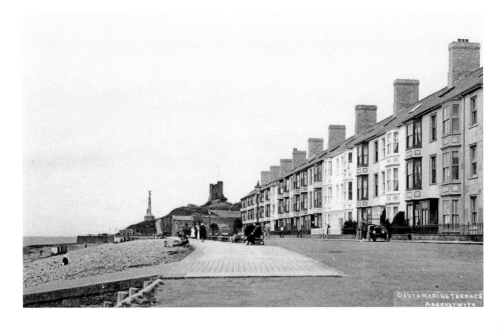

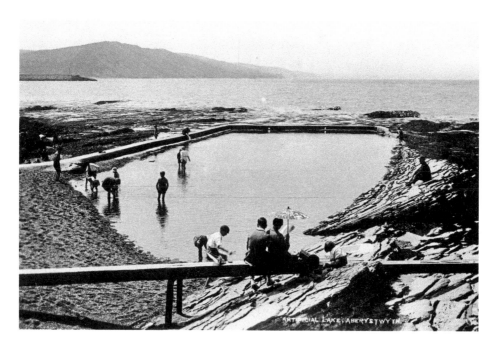

Artificial Lake, Aberystwyth

Built to entertain Edwardian children, the paddling pool at Castle Point was a victim of the storms of January 1938, along with the end of the pier and the promenade at Victoria Terrace. The pool was built between high and low water marks thus ensuring the water was changed twice daily by the tide. In the bottom picture two generations of the Akerman family are enjoying the delights of rock-pooling.

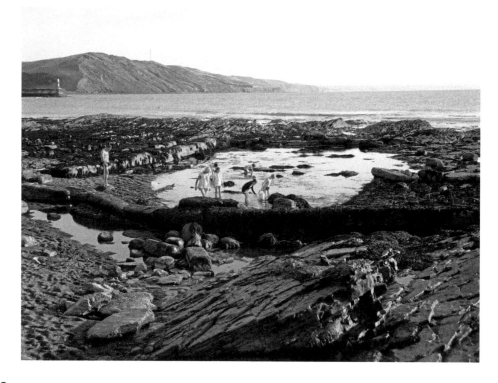

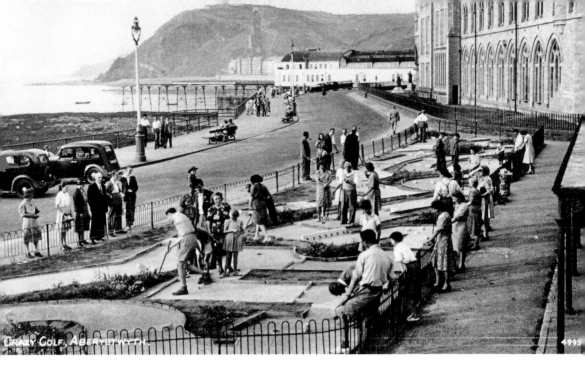

Crazy Golf, Aberystwyth, *c.* 1948

The area now laid out for crazy golf was originally planned to house an aquarium to showcase local marine life. However the plan never came to fruition and crazy golf has flourished there ever since.

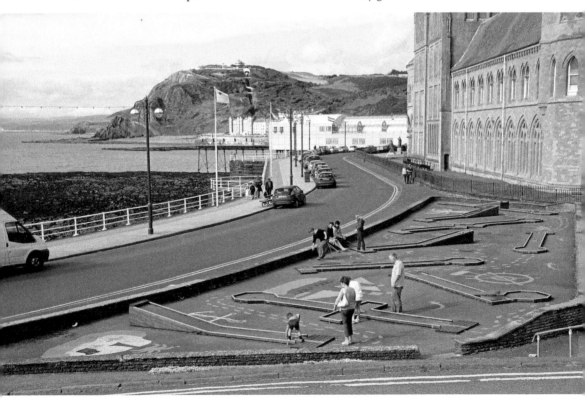

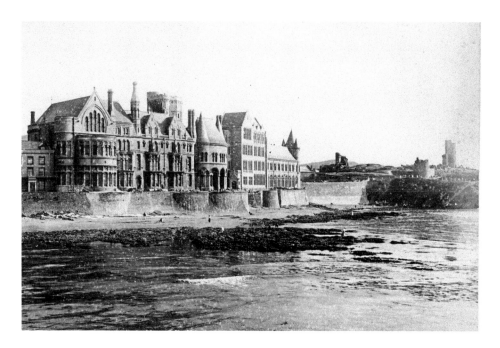

Old College from the Pier, *c.* 1890

For the first forty years of its existence the University was very literally 'The College by the Sea', a proximity that must have given those students not from coastal communities some heart stopping moments. The extension of the promenade from the pier past the University and around Castle Point to South Marine Terrace took place from 1901-1903 at a cost of £16,000. The difference in architectural styles between the original parts of the Old College and the portion rebuilt after the fire of 1885 (on the right) can be seen.

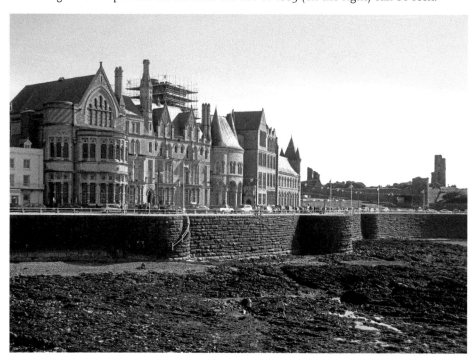

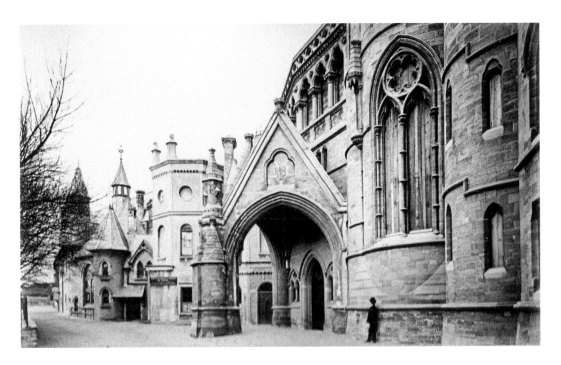

Old College, *c.* 1872

A financial crisis caused by greedy bankers and a government dominated by old Etonians – it must be 2010. Well, no – the same circumstances existed in the 1860s, leading to the downfall of Thomas Savin who commissioned the building of the Castle Hotel in 1865. Two years later, the unfinished building was sold for a fraction of its cost and became the University College of Wales. Notice the boarded up windows indicating the construction work still to be done. A fire in 1885 destroyed many of the features in the left of the top photograph and allowed rebuilding to take place in a fashion more suited to a seat of learning than a hotel.

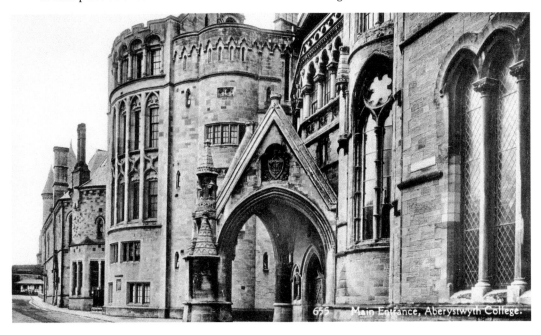

655 Main Entrance, Aberystwyth College.

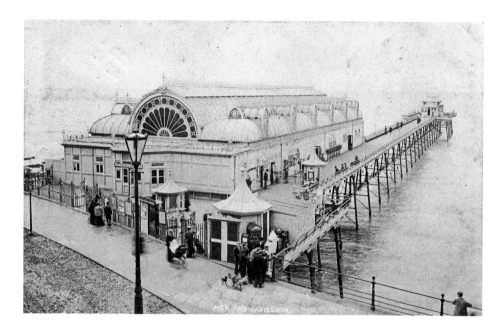

Pier and Pavilion, Aberystwyth

The first purpose-built pleasure pier in Wales opened in 1865, though the Royal Pier Pavilion (capacity 3,000) was not added until 1896. A hundred years ago the pier offered a variety of entertainments such as minstrel troupes, phrenologists, recitals, a bookstall and refreshments. A band played daily at the small pavilion at the end of the pier. Today the pier houses a nightclub, bar, brasserie, snooker hall, DVD rental shop, amusement arcade and Don Gelato ice-cream kiosk.

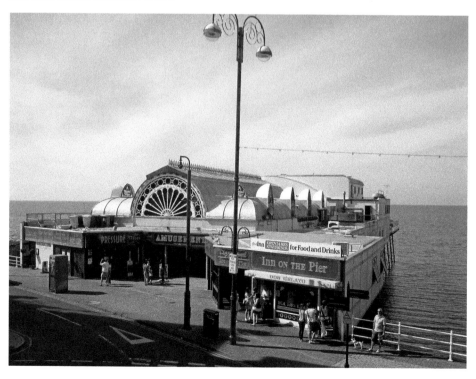

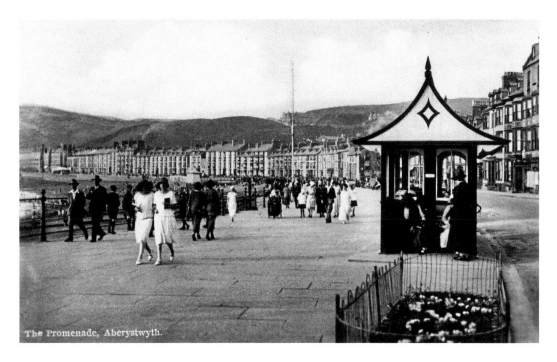

The Promenade, Aberystwyth.

The Promenade, Aberystwyth, *c.* 1925

These two belles in their white dresses are dressed in the height of 1920s fashion. On the right is the newly public shelter erected in 1925 at a cost of £97. At the time the top photograph was taken the Kings Hall was yet to be built, whilst in the bottom photograph it has been demolished and replaced.

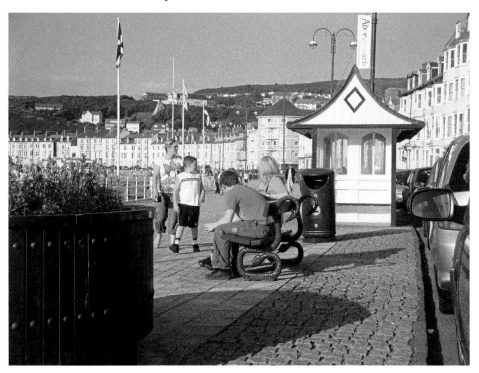

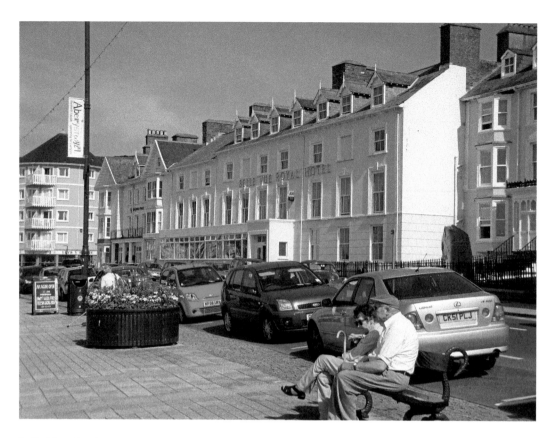

Belle Vue Hotel

The Belle Vue Hotel started life as an annex to the once popular Talbot Hotel, now The Orangery. Its guests have included film stars such as Richard Burton and Elizabeth Taylor. During the Second World War Aberystwyth was home to No. 6 Initial Training Wing of the RAF and some of their trainee pilots were billeted at the Belle Vue. Redecoration of one room in 2007 revealed graffiti by these future airmen. Much of it was technical data regarding aircraft and navigation using the night sky, whilst some of it was more lighthearted, as below. One Aberystwyth merchant seaman reminisced that coming home to Aberystwyth on leave "You couldn't get a girl 'cos the RAF had them all".

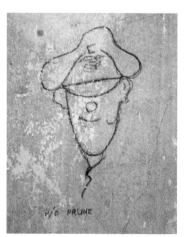

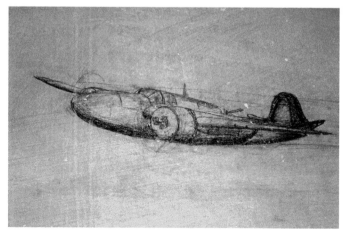

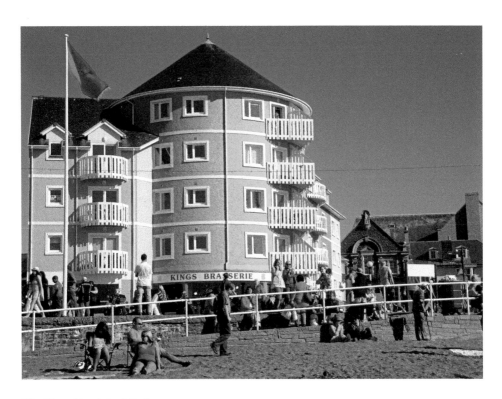

The New Municipal Hall, c. 1934

Built at a cost of £21,000 in 1934, and renamed Kings Hall in honour of King George V's Silver Jubilee the following year, this was Aberystwyth's principal concert hall for nearly fifty years. It housed graduation ceremonies, eisteddfodau, dances, balls, operas and orchestras. Those who have performed there include Rolling Stones (7 September 1963), Moody Blues (6 February 1969), Fleetwood Mac (14 November 1969), Led Zeppelin (16 January 1973 – admission £1), also Elvis Costello, Ian Dury, Nick Lowe & co. (4 October 1977).

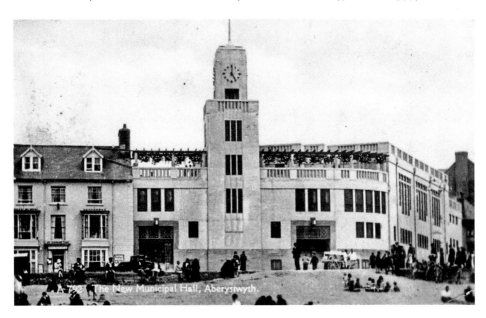

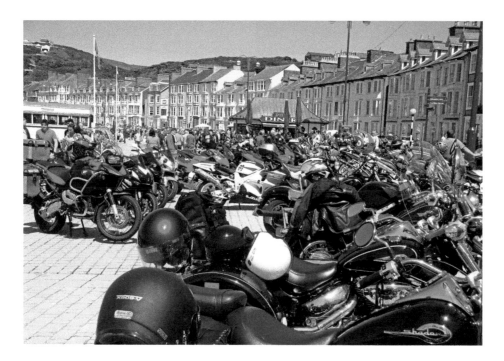

Motorbikes

A newly established category of visitor to have re-discovered the beauty of Aberystwyth are the weekend motorcyclists. These are not the Hells Angels of the seventies but, typically middle aged, well-behaved and often Midlands based people, who come to enjoy the scenery of mid Wales before stopping for refreshments, camaraderie and a chat at PD's Diner on Aberystwyth promenade. Seeing these bikes on the prom it is difficult to believe that Britain has the lowest rate of motorcycle ownership in Europe.

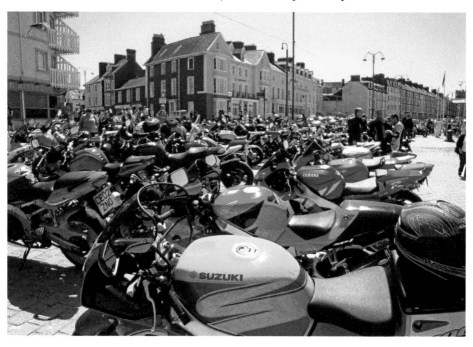

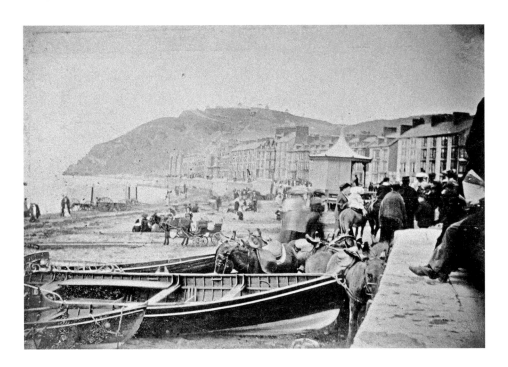

Bandstand and Beach, c. 1900

The main beach is a hive of activity in the top picture with rowing boats, a donkey cart, donkeys and bathing huts on the beach. Today the beach is home to more genteel pursuits such as building sand-castles and snoozing. For some, keeping an eye out for the odd tasty morsel is the order of the day. The present day bandstand is the only one in Britain built in celebration of King George V's jubilee.

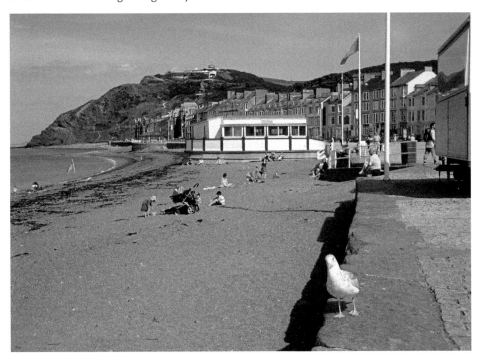

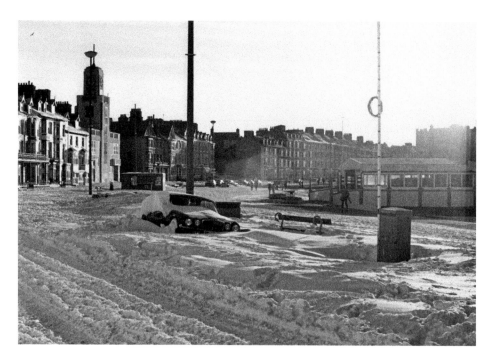

Promenade, January 1982

It may surprise some people to know that the sun doesn't always shine in Aberystwyth. Sometimes it rains and very occasionally it snows. In January 1982 all of mid Wales was caught out by a ferocious blizzard, regarded by many as the worst of the century. Aberystwyth was without road or rail communication for five days, the harbour froze over and even the prom had snowdrifts.

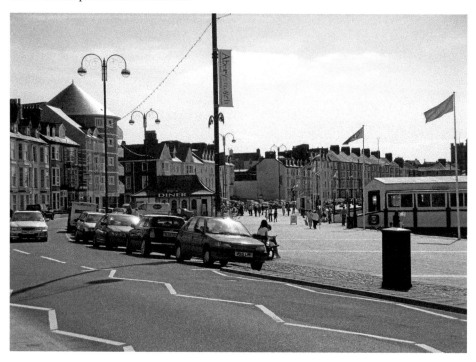

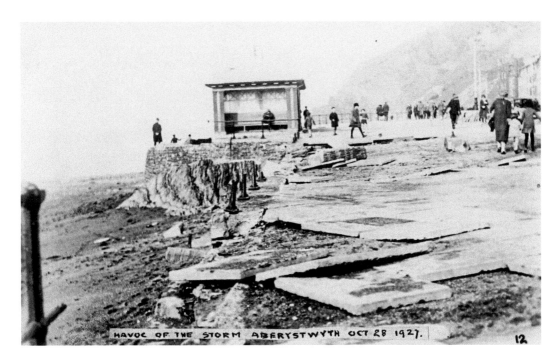

Havoc of the Storm, 28 October 1927

More frequent are the rough seas that batter the promenade, causing minor damage in most years. That in 1927 was the worst since 1887 and did considerable damage to the promenade as seen here. The Bath Rock Shelter in the centre of the bottom photograph is believed to mark the site of the town's medieval gallows. The shelter was also built in 1925, at a cost of £365.

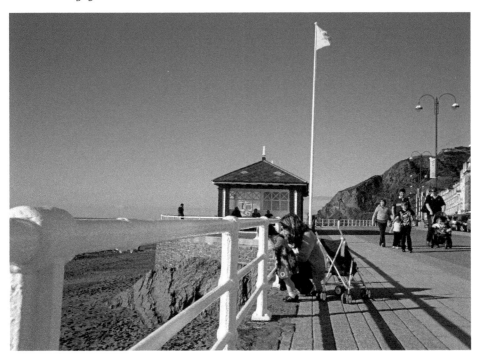

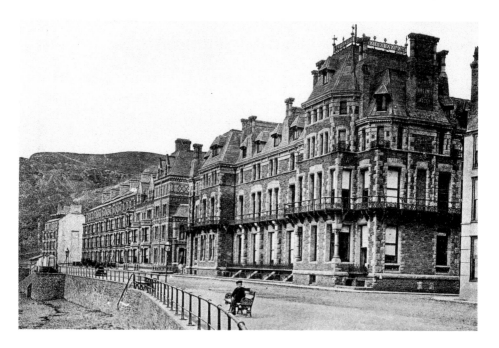

The Queens Hotel

J. B. Balcombe built the Queens Hotel through his "Hafod Hotel Company", having already made a fortune from investments in lead mining. The panels below the Ground Floor windows (visible on the right) contain splendid quartz specimens from his mines. Later, innovative accounting practices at these same mines led to Mr Balcombe being detained at Her Majesty's pleasure for eighteen months. Amongst those known to have stayed at the Queens Hotel were H. G. Wells, in April 1922, and the aviatrix Amy Johnson in June 1933. Sadly, much of the ornamental ironwork has been removed since the hotel closed in 1951. Since then the building has been used as local government offices but now faces an uncertain future.

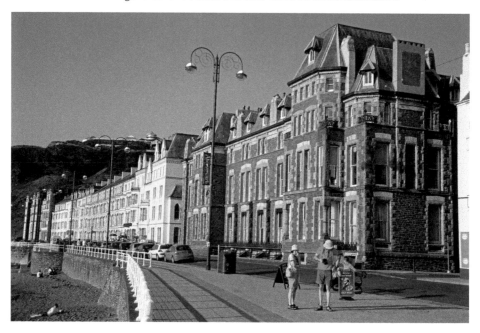

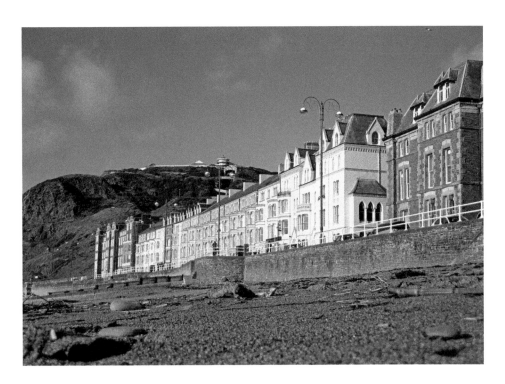

Constitution Hill *c.* 1865

Despite the arrival of the railway in 1864, and the building of the prestigious 'Hotel de Ville' style Queens Hotel in 1866, the promenade to the north took another thirty-five years to become fully developed. Here the extensive quarrying on Constitution Hill and behind present day Queens Road is evident in the bottom photograph. The bathing huts belonged to the Neptune Hotel, later re-named the Boars Head Hotel.

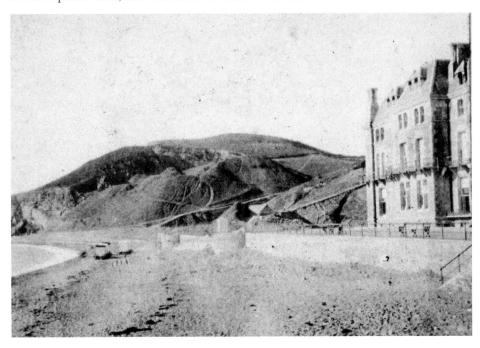

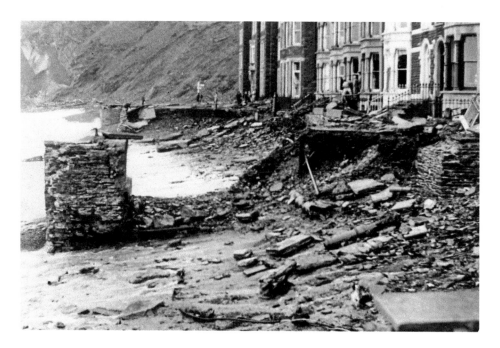

Storm Damage, 1938

Although the storm in October 1927 caused much damage, that in January 1938 was of a far different order. Every property north of the Marine Hotel was damaged and the whole of the promenade in front of Victoria Terrace was washed away, exposing the foundations of the houses. Such was the force of the waves that water hitting the seafront was sent into the air with such force, and in such quantities, that it ran down chimneys and extinguished fires. Today an apron of boulders protects the seawall from a recurrence. Inset – another view of the damage.

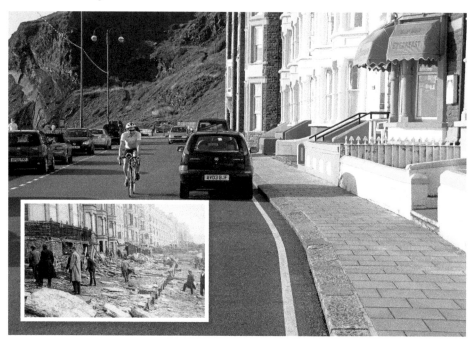

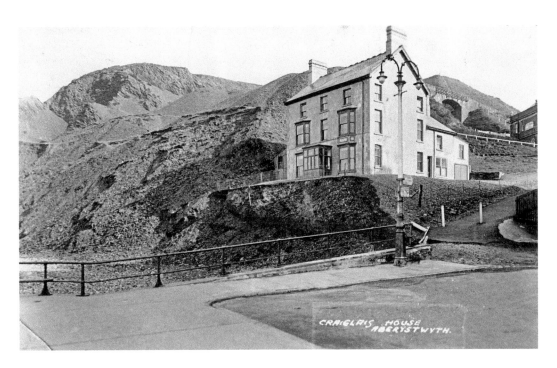

Craiglais House, *c.* 1930

There are no prizes for guessing why Craiglais House is no longer standing. Despite its precarious situation, it survived the 1938 storm and was eventually demolished in the early 1970s. The area has since been landscaped and all traces of the house have gone. The gent in the bottom photograph is engaged in the age-old tradition of kicking the bar, an old Aberystwyth custom whose origin is lost in the mists of time.

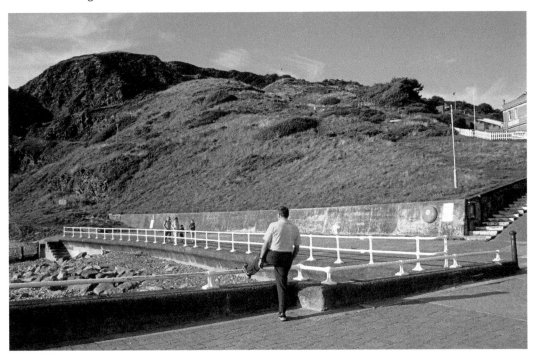

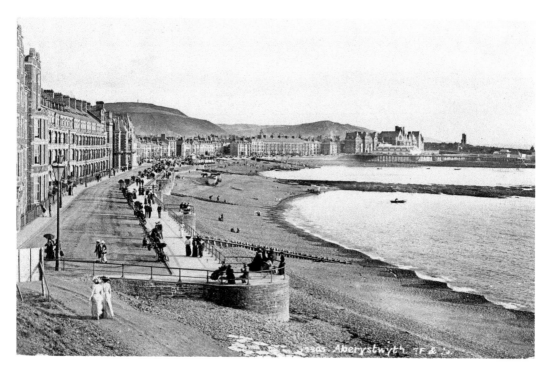

Victoria Terrace, c. 1905

In the top photograph the prom ends in a round turret-like structure with seating. This was rebuilt after 1938 in its present square fashion. During 1990-1991 the prom was given a much-needed facelift and resurfaced. In the bottom photograph the protective apron of boulders in front of the promenade is apparent.

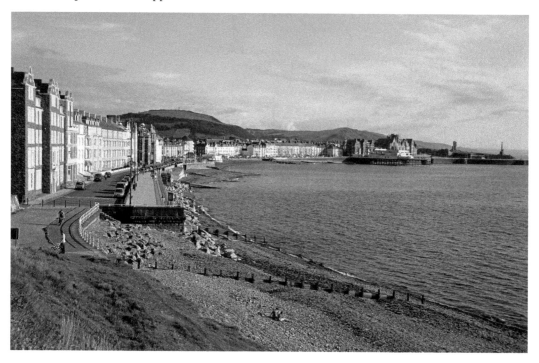

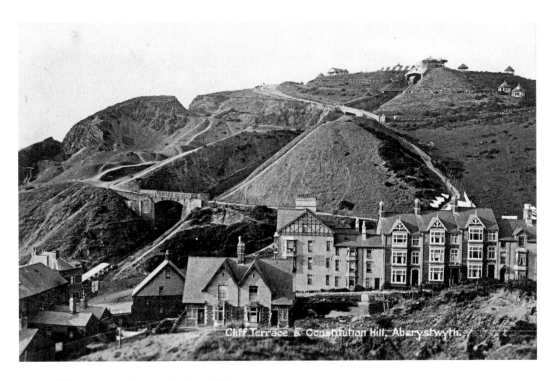

Cliff Terrace and Constitution Hill, *c.* 1920

The building of the 798 ft long Cliff Railway involved the removal of 12,000 tons of rock. The railway opened in 1896 to ferry passengers to a range of attractions called Luna Park on the summit of Constitution Hill. The extent of the subsequent landscaping work to remove much of the quarry waste is visible behind the lower houses in Cliff Terrace.

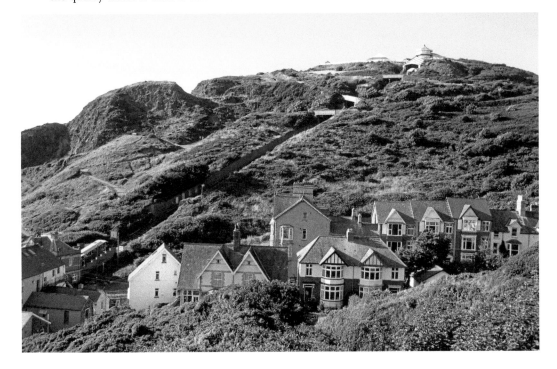

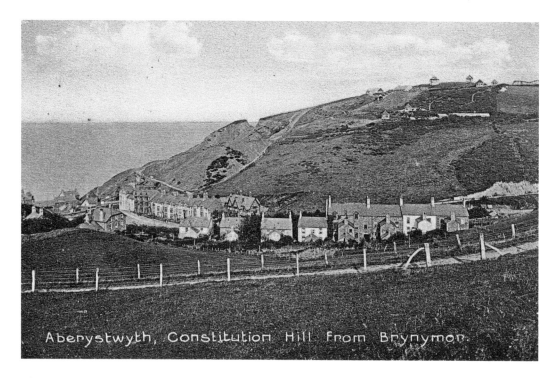

Aberystwyth, Constitution Hill from Brynymor.

Aberystwyth Constitution Hill from Brynymor

The Cliff Railway is still as popular as ever but Luna Park fell victim to a number of poor summers and did not last long. Today Constitution Hill boasts the world's largest camera obscura, visible on the summit and, since 2005, a fine, purpose-built restaurant with views over Cardigan Bay. In the top photograph a number of small pavilions designed to give shelter (from the sun of course) can be seen near the summit.

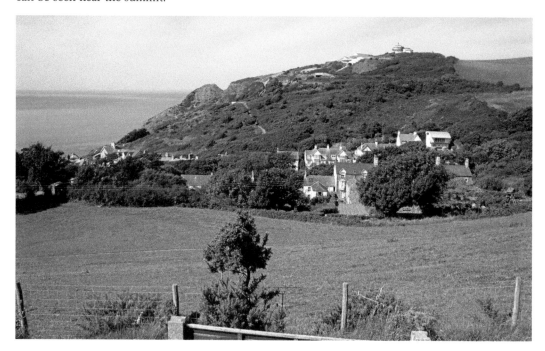

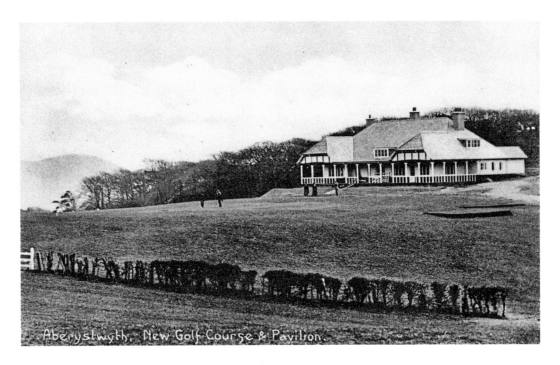

Aberystwyth New Golf Course and Pavilion, c. 1910

Aberystwyth Golf Course opened with ten holes in 1909, expanding to eighteen in 1914. Golf's first international celebrity and six times open champion Harry Vardon planned the course. He also held the course record of 68 for many years before Bert Hodson (a member of Britains 1931 Ryder Cup Team) set a new record of 64 in 1932, only to see local amateur Dick de Lloyd hit a round of 63 a month later. The current course record of 66 reflects the more challenging nature of the course since the heady days of the 1930s.

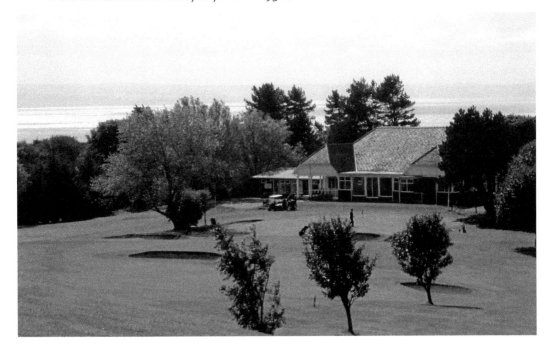

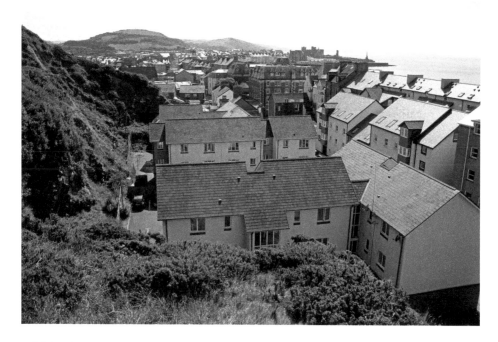

British Telecom Depot, 1990

A hundred years ago this area was a quarry. It was unpopular with local residents and visitors alike due to the noise from blasting and stone dressing. Later it was home to a theatre, appropriately called the Quarry Concert Pavilion. Later it housed the Post Office telephones depot before their transfiguration into British Telecom. More recently the Parc Craiglais development was built on the site. On the other side of Queens Road can be seen the new student housing built after the 1998 fire in the Seabank Hotel destroyed Caerleon and Plynlimon Halls of Residence.

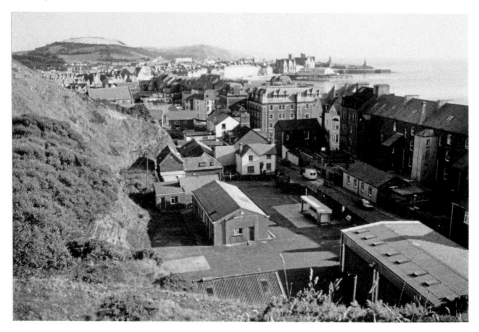

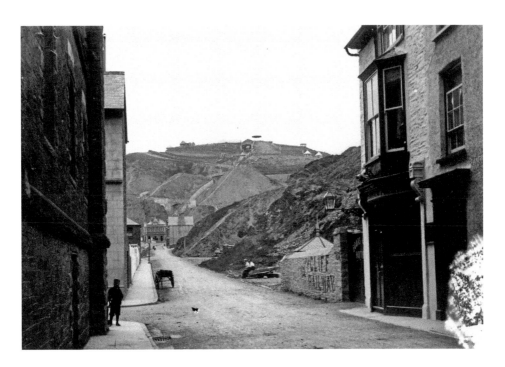

Queens Road, c. 1905

On the right of the top photograph is the Boars Head Hotel, a popular pub until well into the 1990s but following its purchase by the Po Na Na chain went into rapid decline. A century and a half ago it was called the Neptune Hotel but now it is permanently closed and in the process of conversion to flats. Farther up part of the quarry can be seen, now the site of Rocklands and the Parc Craiglais housing development. The Cliff Railway, opened only a few years before, looks in pristine condition.

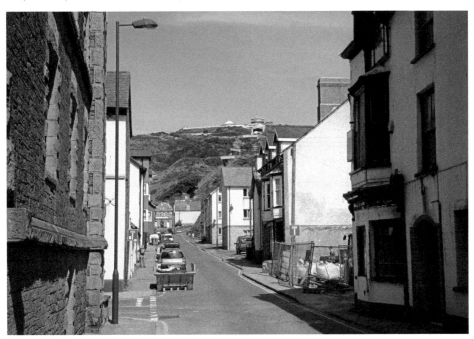

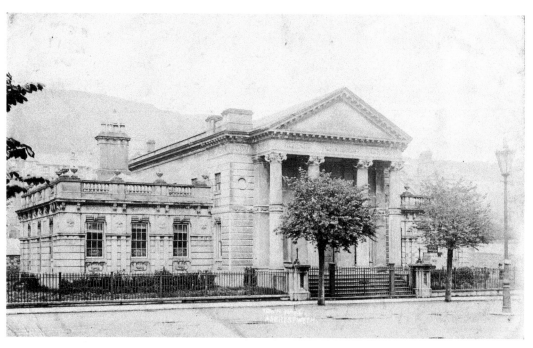

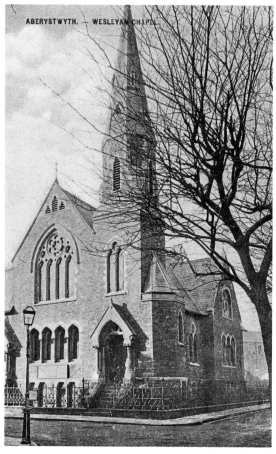

Town Hall, Aberystwyth and English
Wesleyan Methodist Chapel
(both *c.* 1905)
If these buildings look markedly
different today from their counterparts
of a century ago (see opposite) that is
because both have been rebuilt. The
old Town Hall was damaged by fire
in 1957 and rebuilt in similar style
to the original. At present the Town
Hall is undergoing £950,000 worth
of alterations to convert it into a new
library.

Town Hall, Aberystwyth and St Paul's Methodist Centre
Whereas the new Town Hall is reminiscent of the old, St Paul's Methodist Centre is a radical alternative to the Victorian chapel that stood there previously. St Paul's is now home to both Welsh and English Methodists. The name was chosen in deference to the mother church of Aberystwyth Methodism, which has now been converted into a pub and named 'The Academy'.

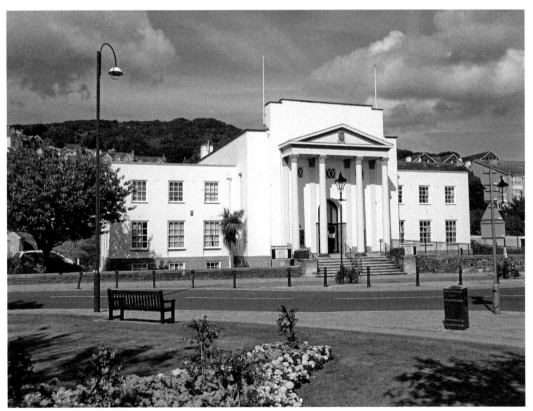

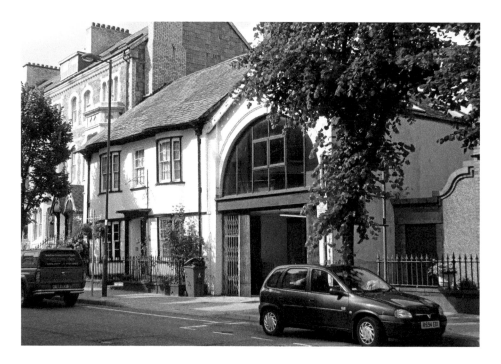

Sandmarsh Cottage, 1971

Sandmarsh Cottage is a Regency style house that still retains lots of character. Next door was one of the earliest garages in Aberystwyth. Known for years as Savage's Garage, and kept by T. H. Savage (who had been an engineer on the Vale of Rheidol Railway) and his son Eddie. They were the local agents for Standard and Morris cars. By 1970 it became the foundation for Meirion Motors, now a much bigger concern out at nearby Glanyrafon Industrial Estate. Today it houses Daton Computer Services.

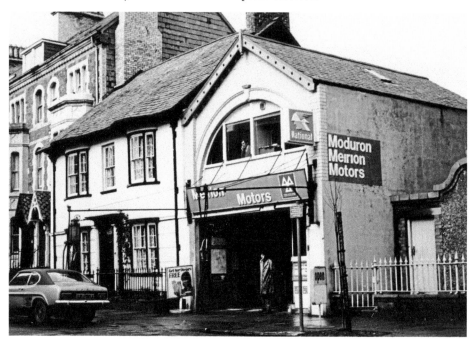

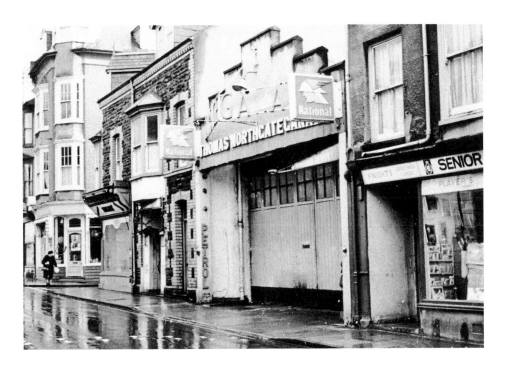

Thomas Northgate Garage, 1971

The 1970s may be unsurpassed when it comes to pop music, but architecturally its legacy leaves a lot to be desired. Thomas Garage in Northgate Street was another of the many small garages that opened following the boom in motor car ownership after the First World War. It had already closed by the time this photograph was taken *c.* 1971. Shortly after it was demolished to make way for Government Offices. Originally the offices housed the DHSS but is now home to the Home Office Identity & Passport Service.

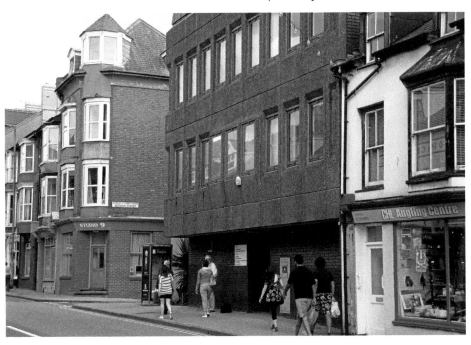

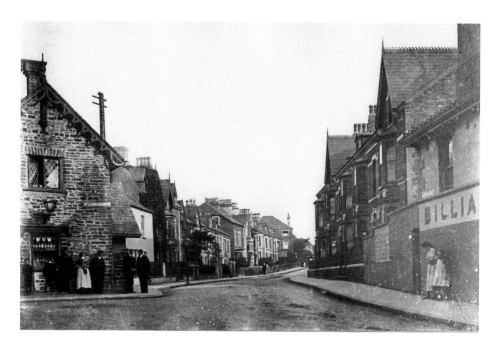

Llanbadarn Road, Aberystwyth *c.* 1910

The tollgates that stood on this site until well into the nineteenth century traditionally marked the boundary between north and south Wales. As road traffic increased the tollgates were removed in 1889, followed by the shop on the left in 1938. Further demolition seemed likely in 1970 when the powers that be unveiled a plan for the site which included demolishing the Coopers Hotel on the right to make way for a roundabout. The plan received short shrift locally and was soon forgotten.

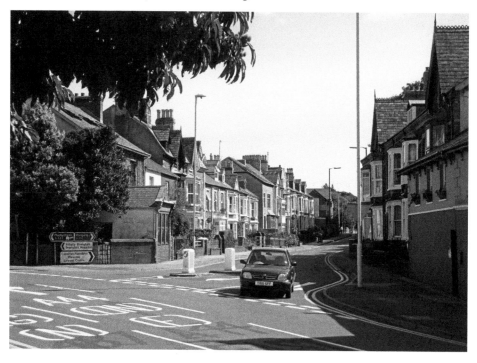

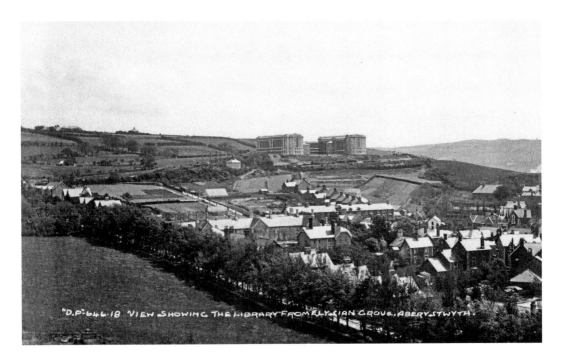

"D.P. 646.18 VIEW SHOWING THE LIBRARY FROM ELYSIAN GROVE, ABERYSTWYTH."

The Library from Elysian Grove, *c.* 1925

In Edwardian times Elysian Grove was an outdoor entertainment venue during the summer months. By the 1930s the area was becoming one of the most sought-after areas to live in. Today, the green fields have given way to housing. In the top left of the bottom view the buildings on the University campus can be seen while Bronglais General Hospital, which admitted its first patients in 1965, dominates the centre of the picture. Building on the Penglais Campus started in 1937.

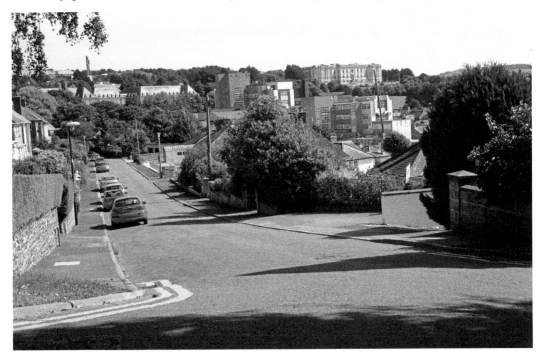

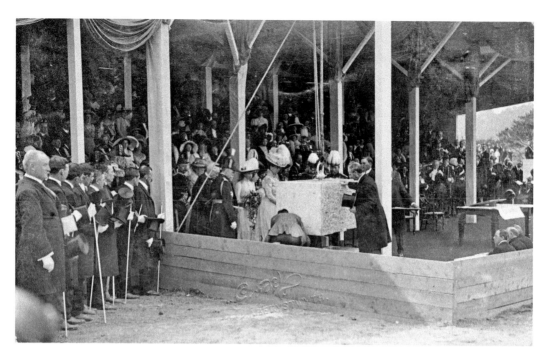

Royal Visits, 1911 and 1996

15 July 1911 was the first visit to the town by a reigning monarch since time immemorial. The newly-crowned King George V and Queen Mary were greeted enthusiastically by huge crowds along their entire route as they made their way to lay the foundation stone of the National Library of Wales. When Queen Elizabeth II visited on 31 May 1996 to open a new extension to the library the visit did not attract such enthusiasm. The Queen is seen here talking to Miss Laura Roberts. Next to Miss Roberts is Cynog Dafis MP.

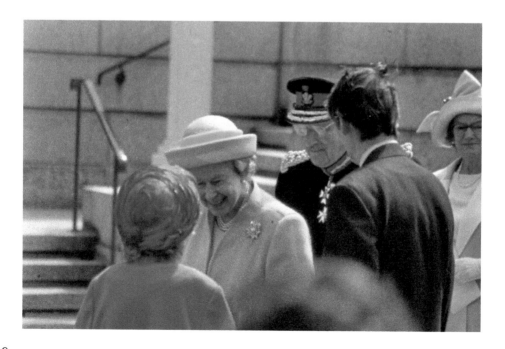

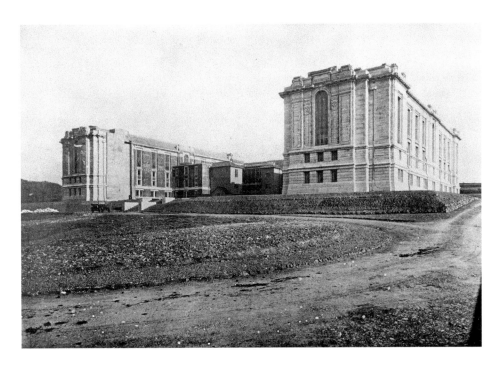

National Library of Wales Exterior, c. 1920

The National Library of Wales received its Royal Charter in 1907. The foundation stone was laid four years later and in 1916 the Library opened its doors to readers for the first time. The central block, missing in the top photograph, was added in 1937. The National Library of Wales is justifiably proud of being a public library in the sense that any person aged sixteen or over is welcome to obtain a reader's ticket and use the collections for reference purposes with little formality and free of charge.

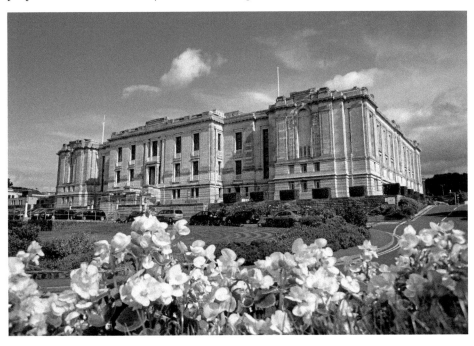

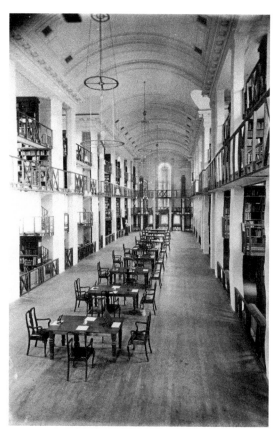

Reading Room, *c.* 1930
The National Library of Wales now holds over 4.5 million books, a million maps, 800,000 photographs, 60,000 works of art and 40,000 manuscripts. It has 120 miles of shelving and if all the books were piled one on top of another they would be 33 times higher than Mount Everest. The north reading room (top picture) has recently undergone a £750,000 facelift and now offers five study areas, free wi-fi and a lounge area that offers views over Cardigan Bay.

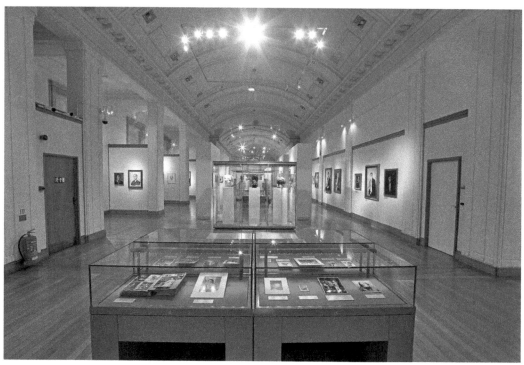

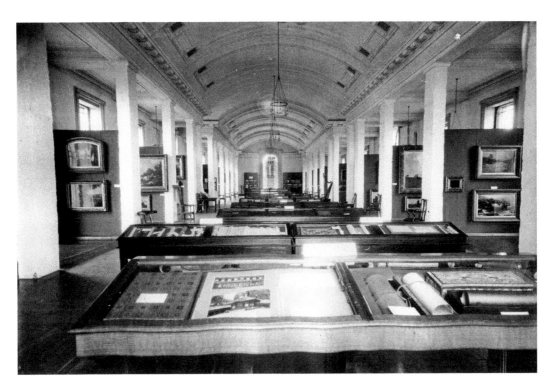

Gregynog Gallery, *c.* 1930

Even though a great deal of the Library's holdings are available on their website, exhibitions in the Gregynog Gallery are still hugely popular. The gallery was so named in recognition of the generosity of the Davies sisters of Gregynog, who were generous benefactors to the library. Want to see more? Then sign up for one of the free weekly tours of the library, or even better enrol as a reader (it's free) and see the holdings for yourself.

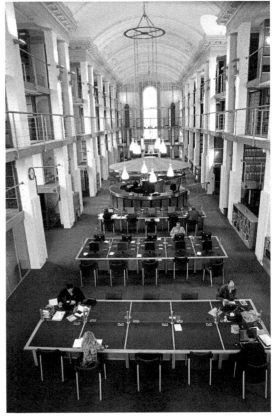

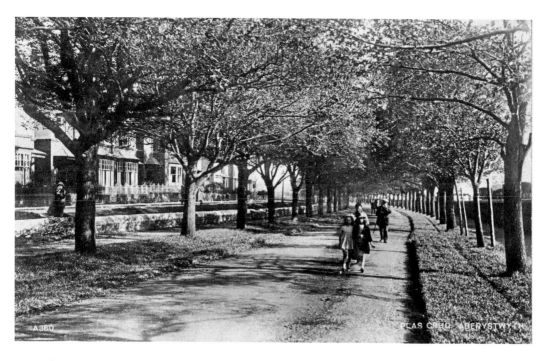

Plas Crug, Aberystwyth, *c.* 1905

Plascrug Avenue was laid out at the turn of the twentieth century for the use of pedestrians and cyclists. It links Aberystwyth with the settlement of Llangawsai, midway between the town and Llanbadarn Fawr. It also provides pedestrian access to three local schools. The name 'Plascrug' was taken from the small fortified house that stood at the end of the avenue, see insert. Some historians have linked the building to Llywelyn Fawr. It was demolished in 1968.

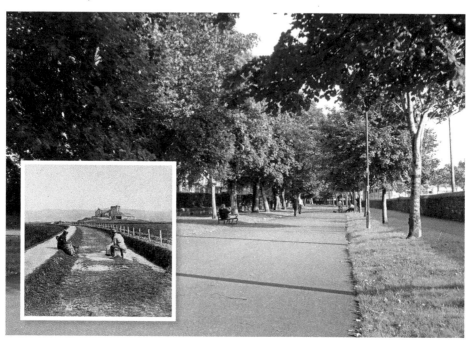

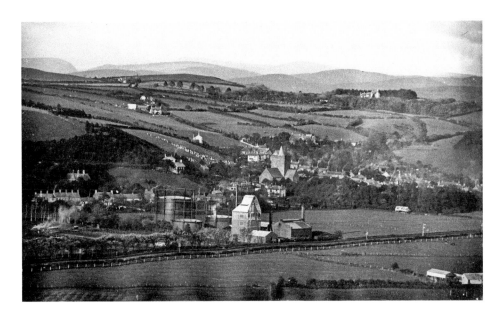

Llanbadarn from Penparcau, c. 1920

The only identifiable landmark in the top photograph that remains is Llanbadarn Church. The gasworks, opened in 1900, are now a biomass plant that provides heating and hot water to the new Welsh Assembly Government Offices (extreme left) and adjacent new Ceredigion County Council Offices. Eventually it will also provide energy for nearby Plascrug Leisure Centre and Penweddig Secondary School. Behind the church is the campus of Coleg Ceredigion and also Aberystwyth University's Llanbadarn campus. The railway line can be traced in the bottom photograph by the line of trees across the foreground.

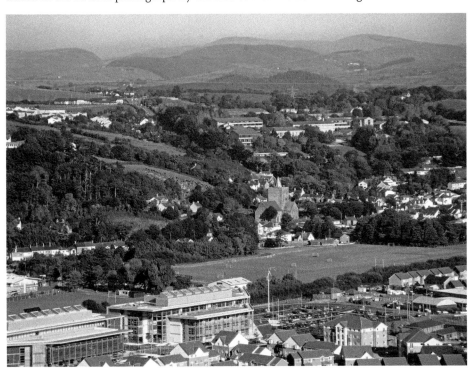

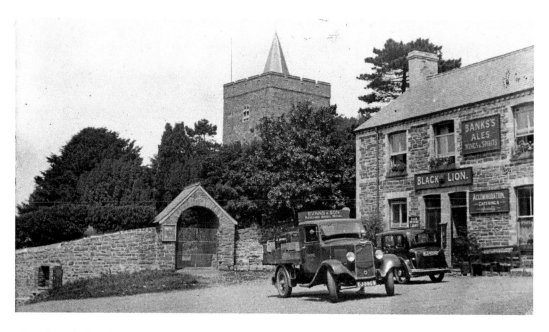

Church and Black Lion, Llanbadarn Fawr

Llanbadarn Fawr Church, now almost entirely hidden by trees, dates back in its present form to the fourteenth century. The Black Lion is also of some antiquity. The name derives from the Pryse family of Gogerddan, local gentry and once wealthy landowners. Until late in the nineteenth century it was a one-storey thatched building.

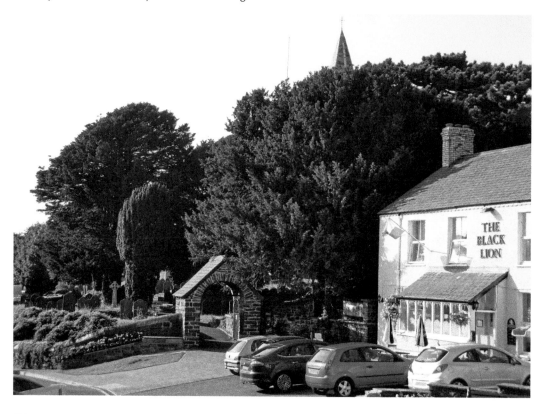

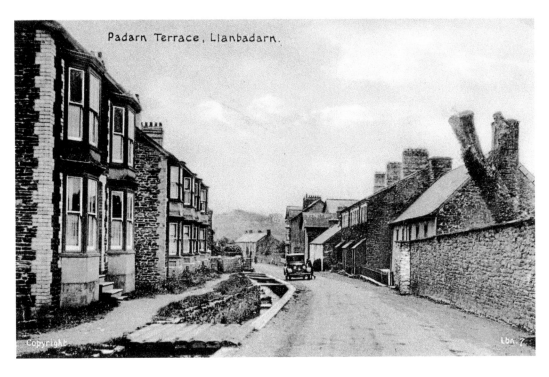

Padarn Terrace, Aberystwyth, *c.* 1925

Llanbadarn Fawr once had far more taverns than the two in the village today. The nearest building on the right was one such establishment, known as Ty Mawr. Note the brook running in front of the houses in the top photograph and now covered over.

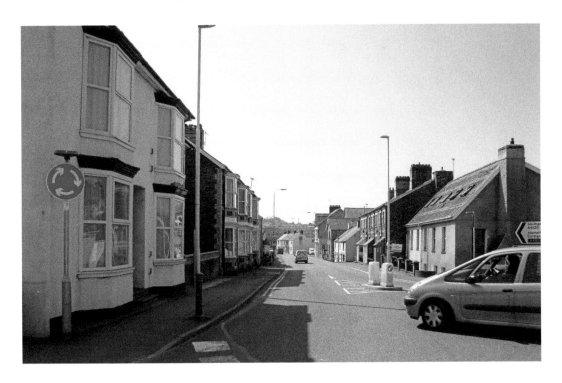

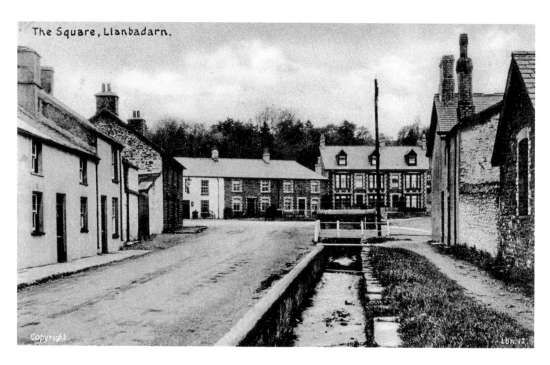

The Square, Llanbadarn.

The Square, Llanbadarn

Three more of Llanbadarn's taverns were located around 'The Green', the area in front of the terraced houses in the photograph above. The partially obscured building on the centre left is the Gogerddan Arms whilst further to the right, where the two larger houses stand, was once the site of the 'Six Bells'. The gable end in the right foreground was once the Talbot, but it now lies under the road.

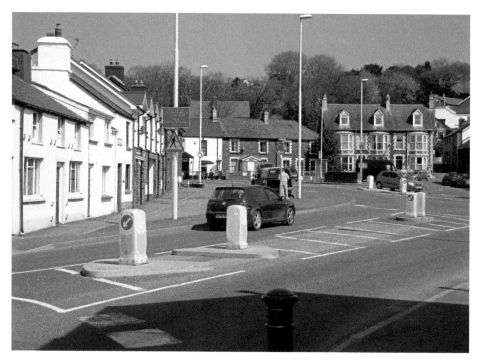

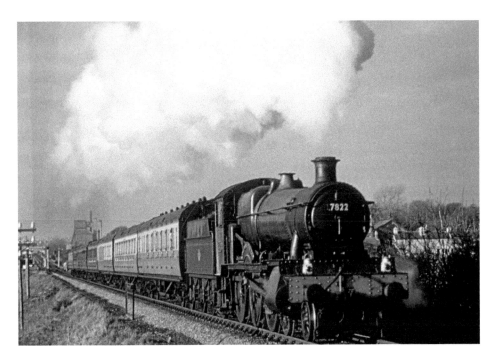

Railway Crossing, Llanbadarn Fawr, *c.* 1965

Today's diesel train (complete with the driver's lunch hanging in the front window) is a poor substitute for the romance and excitement of a smartly-painted steam locomotive such as *Foxcote Manor* seen here hauling passenger coaches. This particular engine is now working on the Llangollen Railway. The last scheduled passenger service to be pulled by steam on the Cambrian Coast was in 1967.

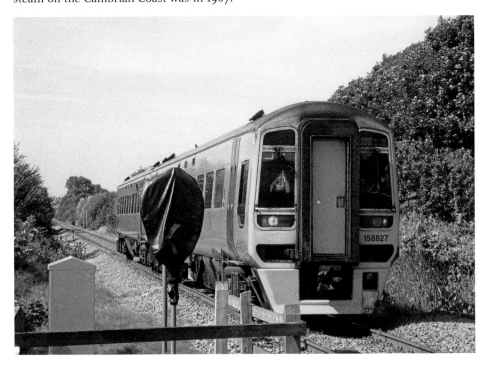

Parc y Llyn Roundabout, *c.* 1995
Plans for Aberystwyth's first out of town retail centre, Parc y Llyn, started to appear about the time this photograph was taken. The name Parc y Llyn derived from a farm in the vicinity now subsumed under housing. These cottages at Parc y Dolau were also demolished.

Road to Nowhere, c. 1995

Aberystwyth's "road to nowhere" was the subject of much hilarity for many years until the Parc y Llyn development finally became a reality. In the top photograph the appropriateness of the name Parc y Llyn (llyn is Welsh for lake) is obvious. The building on the left is a new office block built for the Welsh Assembly Government. Farther down is Canolfan Rheidol, Ceredigion County Councils new £15m office block.

City Road, Penparke, *c.* 1910

When the unknown photographer who took the bottom view sarcastically called it 'City Road' he had no idea that a century later Penparcau would have a population of over 3,000 souls, a post office, two small supermarkets, a garage, holiday park, hotel and, until recently, two fish and chip shops. At the time the photograph was taken Penparcau was a sleepy village of small whitewashed cottages with no sign of the housing estates that were to follow.

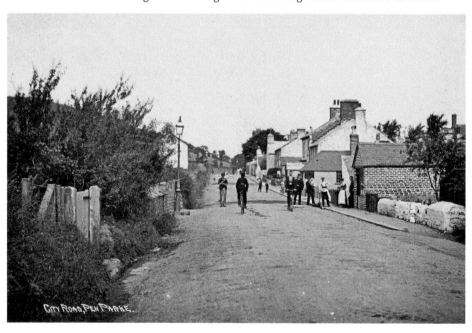

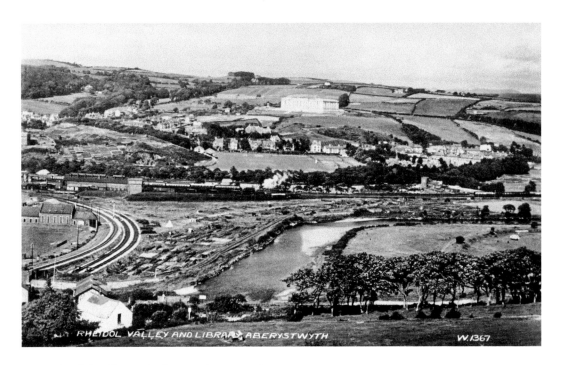

Rheidol Valley and Library, Aberystwyth

The most striking change in this view is the new Police Station and Territorial Army centre in the foreground built on the site of the old Aberystwyth – Carmarthen railway line. However – moving from left to right – the Crown Buildings in Plascrug, the Brynderw halls of residence, Bronglais hospital and the University campus all testify to the changes that have taken place since the top photograph was taken fifty years or so ago.

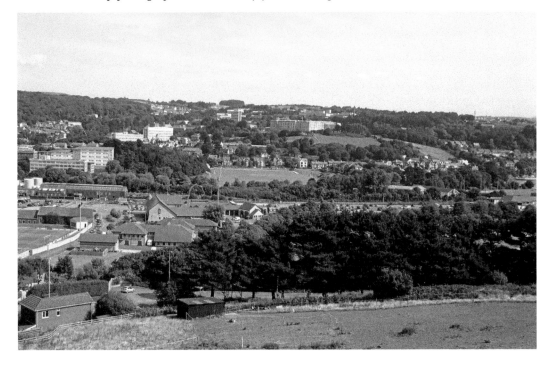

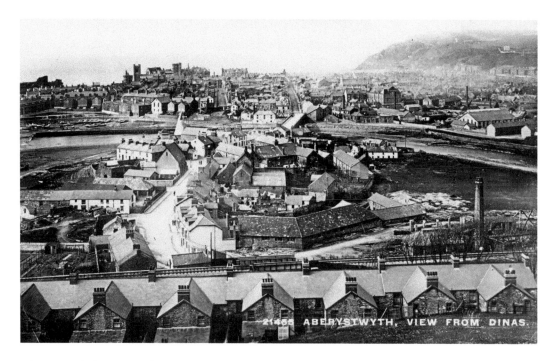

Aberystwyth from Pen Dinas, *c.* 1905 and *c.* 1920

These two views from Pen Dinas show how much housing was built during the early years of the twentieth century, especially Glanrafon Terrace and Spring Gardens. The complex of buildings in the centre of the top photograph was David Roberts & Sons Ltd, the local brewers. As well as the timber yard in the foreground of the photograph, Trefechan was home to a number of small industries such as boat building, sawmills, limekilns and a foundry. The railway line in the foreground was the Aberystwyth–Carmarthen line.

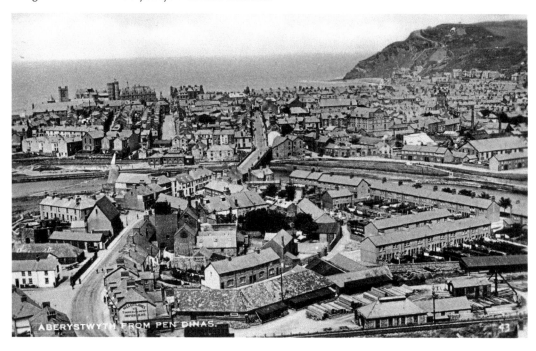

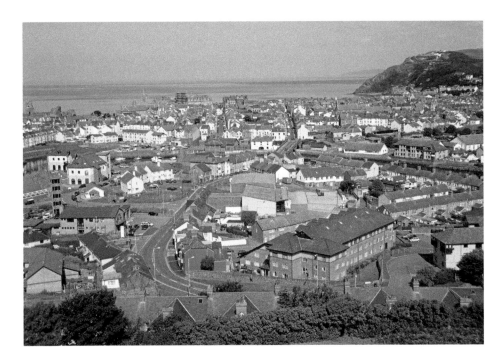

Aberystwyth from Pen Dinas Today

Apart from the disappearance of the railway line the main changes to be seen in Trefechan in recent years are the building of Gerddi Rheidol on the site of J. D. Lloyd's timber yard. This is the three storey brick building centre right of the top photograph. Other developments include offices overlooking the marina, top left. Full marks should go to the local artist who brightened up this gable end in Spring Gardens.

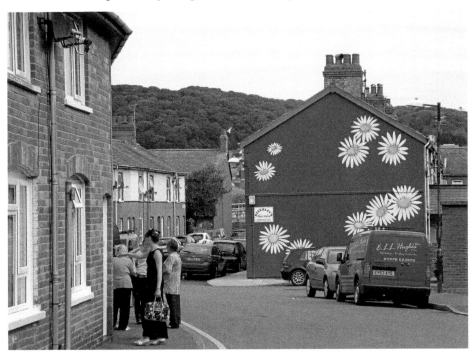

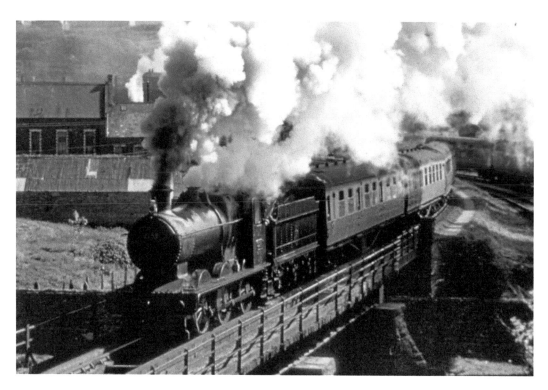

Train Crossing the Rheidol, *c.* 1955 and Park Avenue, *c.* 1920

In the top photograph locomotive 2258 is pulling the Carmarthen train over the River Rheidol before crossing the Penparcau road, skirting Pen Dinas and on to Llanrhystud Road Station. The bridge piers were still visible until a few years ago. Park Avenue, since 1907 the home of Aberystwyth Town FC, can be seen on the left but is better illustrated in the view below.

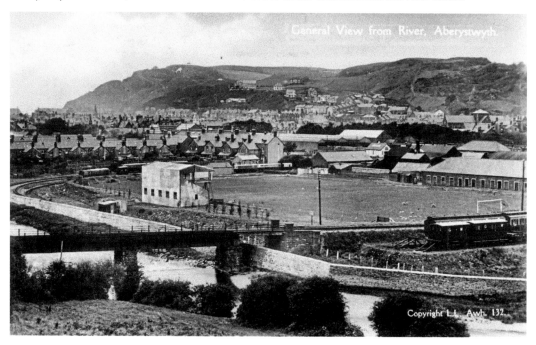

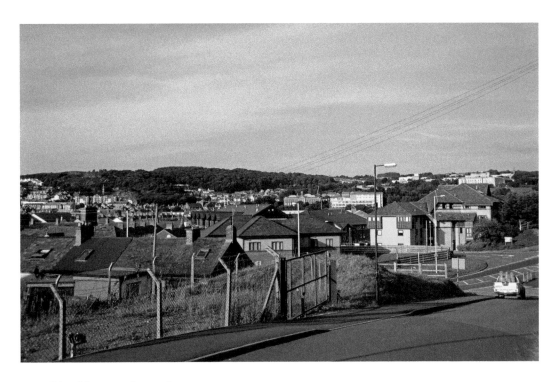

Diesel Locomotive, 1963

The Aberystwyth–Carmarthen line opened in 1867 and closed on 22 February 1965. The 57-mile journey to Carmarthen took a little over three hours to complete. Seen here eighteen months before closure is a British Rail Class 35 diesel, a type of locomotive built especially for the Western Region of British Rail. When the photograph was taken the engine had a livery of dark green with a lime green stripe at the bottom and white windows. Today this part of the track bed is waste ground and used for storing boat trailers.

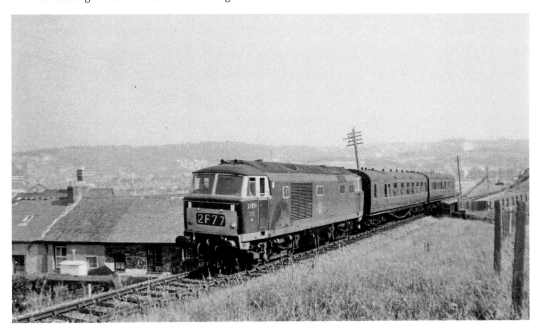

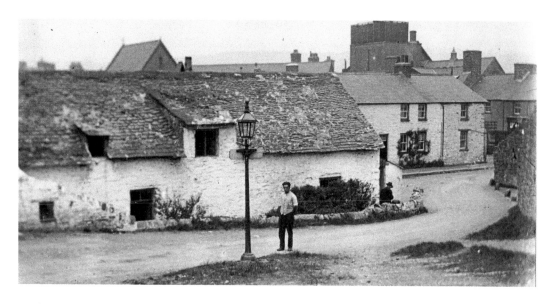

Trefechan, c. 1935

The long whitewashed building in the top photograph was Lavin's lodging house which was in business until after the Second World War. It is now the site of the fire station. The square black tower was part of Roberts Brewery ice-making plant. Zidon stores is now the only building visible in both pictures.

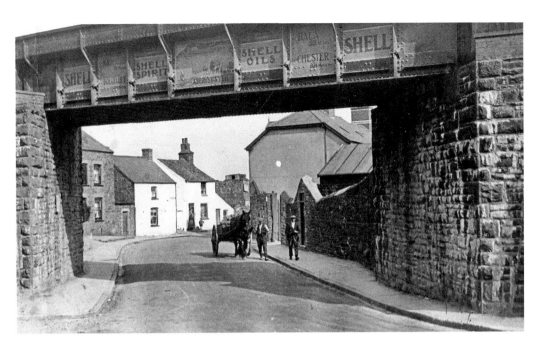

Trefechan Railway Bridge, *c.* 1925

Just as recent developments have led to the demolition of buildings, so it was in the 1860s. In order to build this bridge a pub called the Beehive was demolished, but its name survives through Beehive Terrace, the row of cottages on the extreme left. Note the road distances painted on the top of the bridge. Due to road improvements, some of these journeys are now much shorter, for example the distance to Chester is now ninety-five miles, six miles shorter than in 1925.

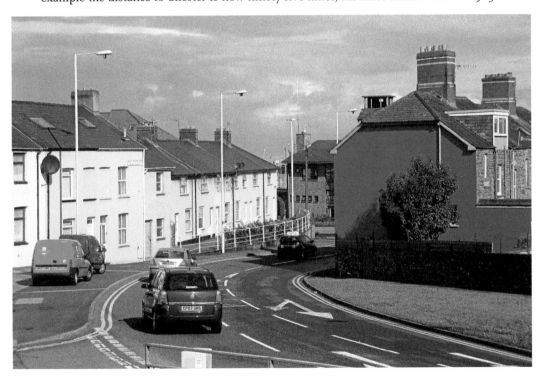

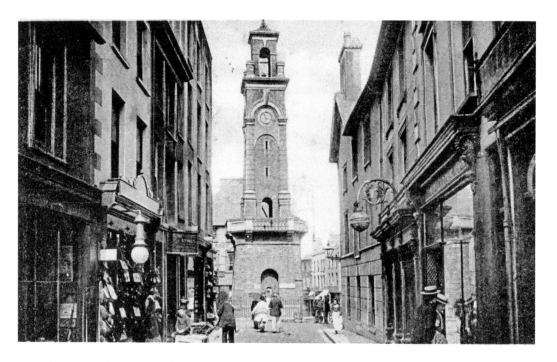

Aberystwyth Town Clock, *c.* 1905

If the town clock looks different today that's because it is a totally different structure. The original clock was demolished amid howls of protest in 1957. Today's clock was built to celebrate the millennium. One of its features is the original water fountain from the old clock. It was the gift of Reverend John Williams in the hope that it would dispense with the need to enter one of the numerous pubs nearby when in need of a drink.

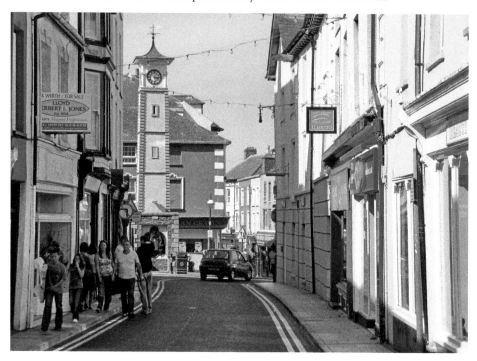

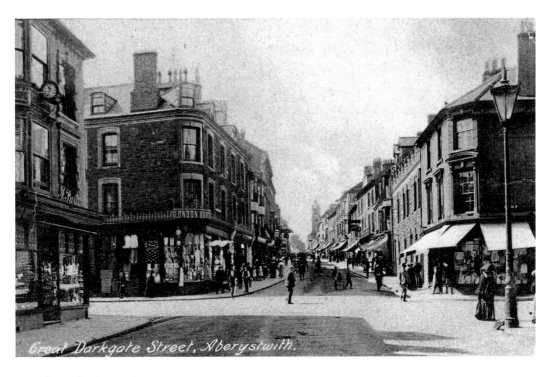

Great Darkgate Street, *c.* 1910

When Aberystwyth had a town wall (about the time Columbus landed in America) one of the main gates into the town stood at the bottom of this street, hence its name. All trace of the town walls disappeared centuries ago, but the medieval street pattern it left behind has remained.

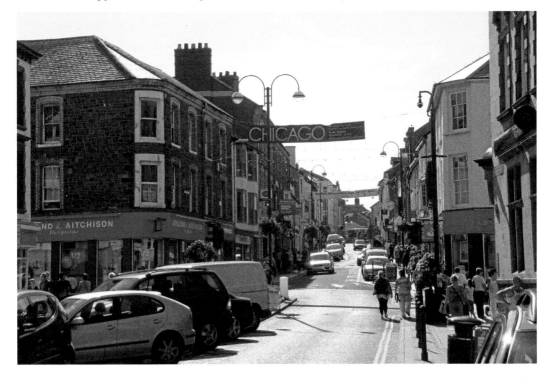

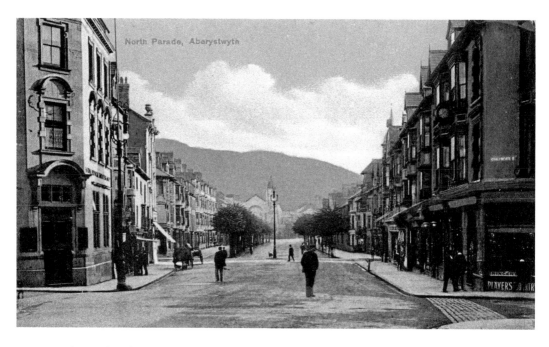

North Parade, Aberystwyth, *c.* 1905

This portion of North Parade was recently renamed Sgwar Glyndwr in honour of Owain Glyndwr, who captured Aberystwyth Castle in 1404. As he then burnt the town to the ground it may seem a curious name for a street here. On the left in the top photograph is the National Provincial Bank, built in 1903 and now the National Westminster Bank, whilst in the centre the original frontage of Seilo chapel is visible.

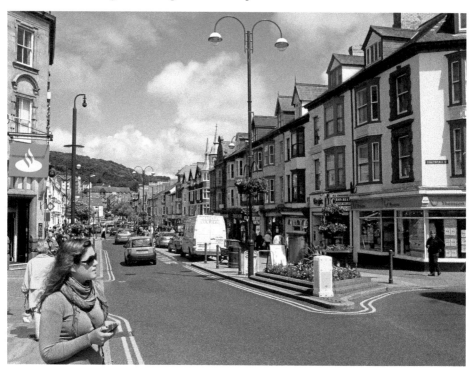

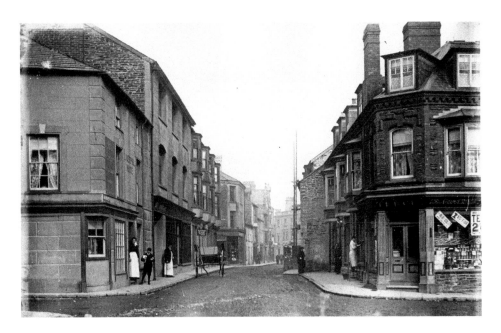

Chalybeate Street, *c.* 1900

There are not many streets in Aberystwyth named after mythical Greeks but Chalybeate Street is one. Chalybes were a mythical people who inhabited Mount Ida in North Asia Minor and invented iron-working. Chalybeate Wells, i.e. those whose waters contain iron salts, were all the rage in late eighteenth-century Britain. Miraculously, such a spring was found in Aberystwyth in 1779 and Chalybeate Street, despite being 200 yards away, was so named. Today the street is one of Aberystwyth's most vibrant, with a host of locally-owned businesses. The spring is believed to be buried somewhere under the railway station.

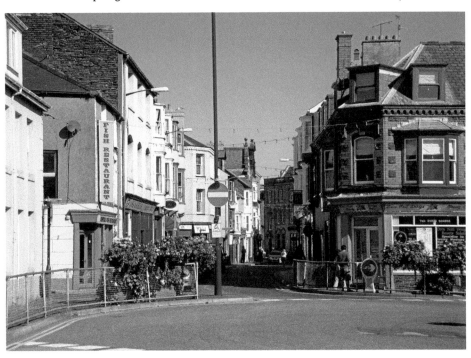

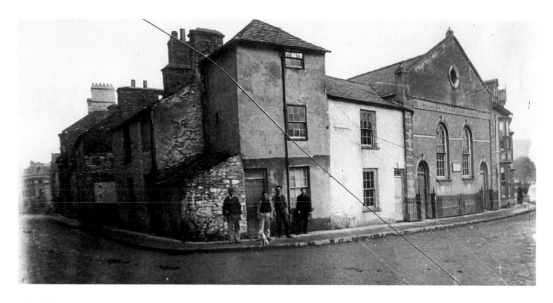

Chalybeate Street, *c.* 1900

These buildings at the corner of Chalybeate Street have an interesting history. What is now the Salvation Army headquarters was built in 1844 as a joint chapel and school by the English Wesleyans in the town. It could seat a congregation of 170. The tower on the corner was also a school, a Commercial and Mathematical School kept by John Evans. His school taught children and adults, the latter mainly sailors wanting to gain a masters certificate. In the bottom photograph the hard work put in by the Parks and Gardens Department of the local council is all too evident.

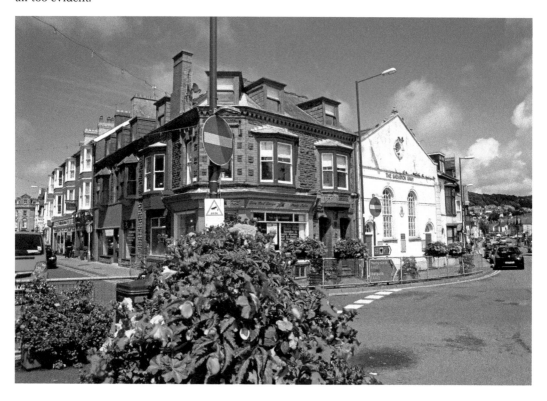

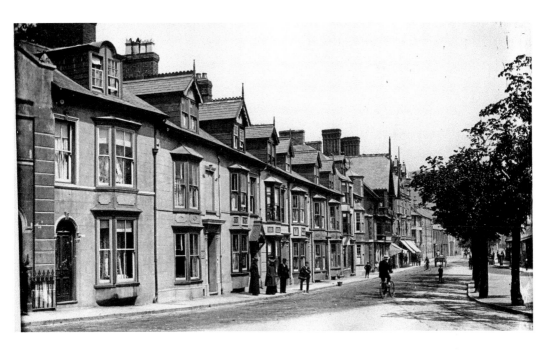

Alexandra Road, *c.* 1910
Until the visit to the town by Princess Alexandra in 1896, this street was known as Lewis Terrace, after David Lewis who built the houses on the left between 1820 and 1830. What is now the Cambrian Hotel half way along the street was called the Commercial Hotel at this time.

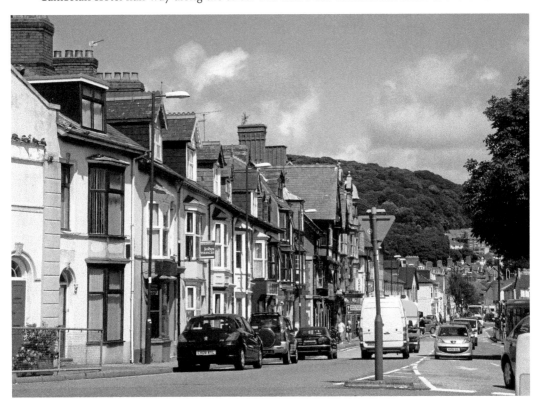

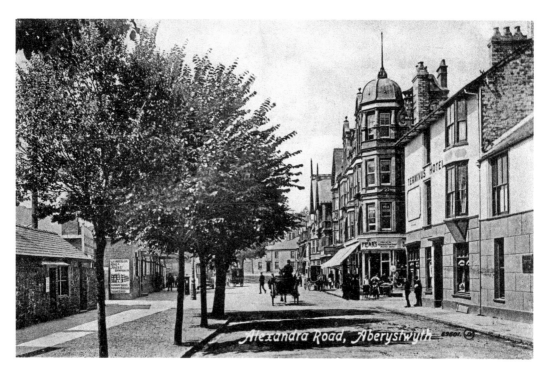

Alexandra Road, Aberystwyth *c.* 1910

The right-hand side of these views has changed little, though what was the Terminus Hotel is now the more imaginatively named Vale of Rheidol, and Fear & Sons (Fishmongers, Fruiterers, Greengrocers, Poultry & Game Dealers) is now the Express Fish & Chip Restaurant. On the left-hand side of the top view can be seen part of the railway station prior to its rebuilding in 1923.

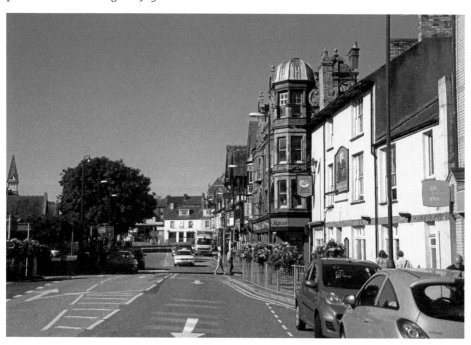

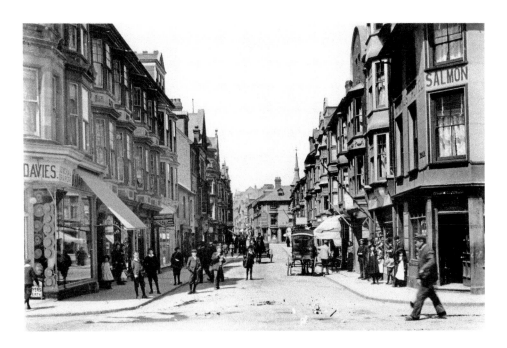

Terrace Road, *c.* 1900

Being the main thoroughfare from the railway station to the seafront, Terrace Road was an immensely popular location for shops when this photograph was taken, *c.* 1900. Terrace Road boasted numerous refreshment rooms, hairdressers, fancy goods' shops, drapers and confectioners. The Terminus Hotel, on the right, was the first public house in Aberystwyth to have an autopiano, a forerunner of the jukebox, a device derided by the editor of the local newspaper as a complete waste of money.

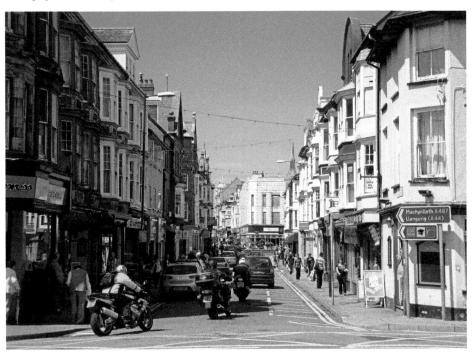

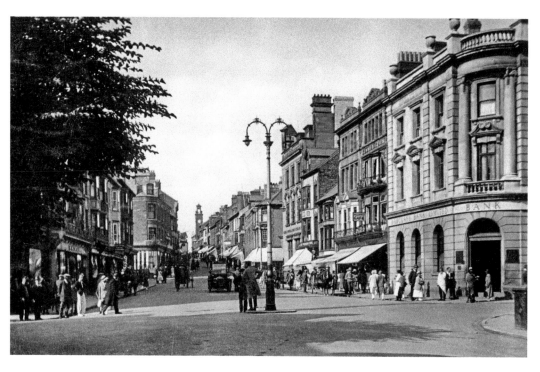

Great Darkgate Street and North Parade, *c.* 1930
Barclays Bank has been in the same building since 1877, although it has grown through purchase of the adjacent Caprice Restaurant. Other businesses in this part of town in the 1930s included the County & Boro' stores and H. Hughes, butcher.

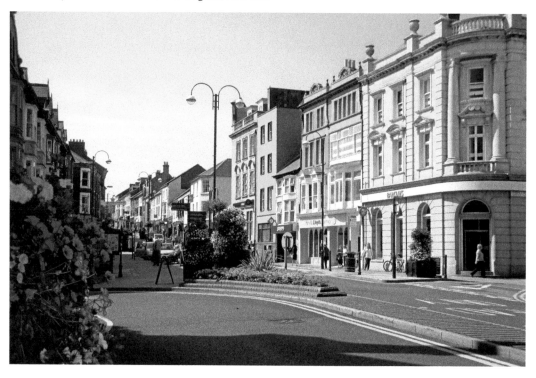

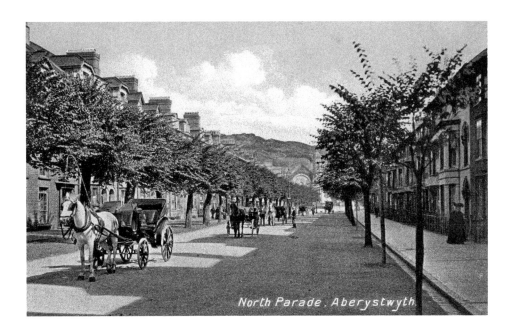

North Parade, Aberystwyth

North Parade, Aberystwyth

North Parade got its name from being used as a parade ground by the local (unkempt and unshaven) militia. However, it had been built on by the early 1830s and was favoured by the wealthier inhabitants of the town. In the top photograph rows of elm trees line each side of the road. Sadly these succumbed to Dutch Elm Disease and were removed *c.* 1970. The centre of North Parade was where landaus, horse-drawn four-wheel carriages, could be hired, akin to taxis of today.

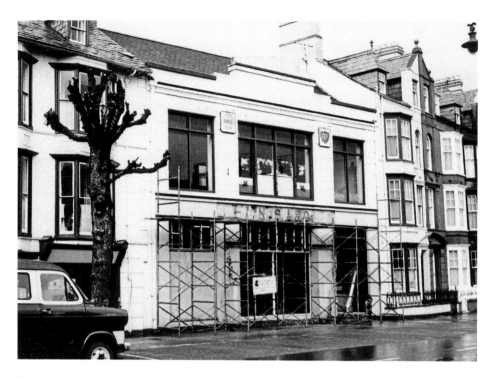

Two Garages, *c.* 1971

For much of the last century there were two garages at the bottom of North Parade. R. Jones & Sons evolved from a coach-building business and is now a dentist's surgery. Today the sale of petrol in such close proximity to housing would not be permitted, even though concerns were raised about the matter as far back as 1906. Gwalia Garage, once agents for Austin and Wolseley cars, is now the site of flats (though in between it was the largest sporting goods' shop in Wales – see next page).

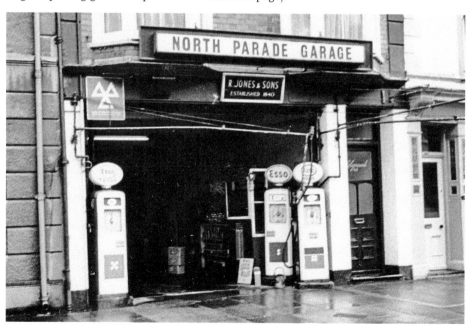

Seilo, c. 1990

Seilo experienced structural problems from the earliest days of its construction in the 1860s. The fact that the area on which it was built was then known as Sandmarsh Lane explains why. The white pillared façade was completed in 1963 to replace a handsome but unsound predecessor. Structural instability made demolition of the whole building inevitable. The adjoining Sunday School was converted to the Morlan Centre for Faith and Culture which opened in 2005. The old hospital, visible behind Seilo has now been replaced by the Parc Y Bryn development. On the left is Y Canolfan Chwaraeon, once Wales' largest sporting goods' shop.

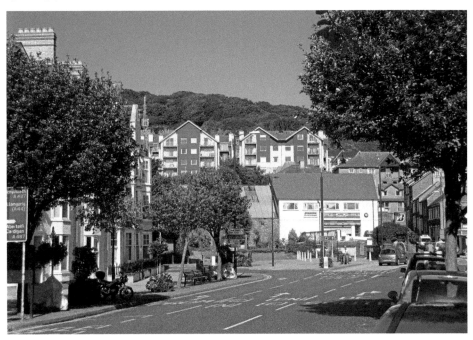

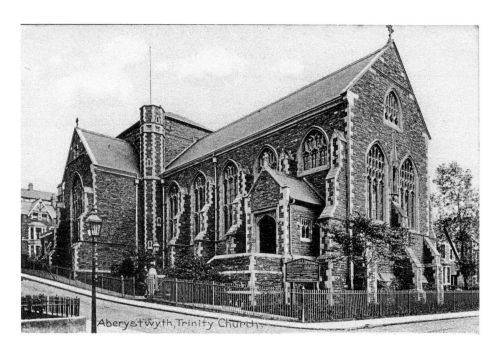

Aberystwyth, Trinity Church.

Holy Trinity Church, *c.* 1905

As Aberystwyth prospered and grew during the late nineteenth century, so did the need for suitable churches. Holy Trinity was built to serve the growing needs of the town, especially as St Michael's was now too small to serve the growing population (see page 95). The following year a new parish, Holy Trinity, was carved out of the parish of Llanbadarn Fawr, In 2011 Holy Trinity will be proud to celebrate its 125th Anniversary.

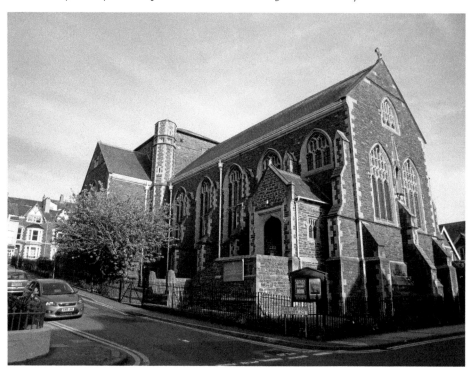

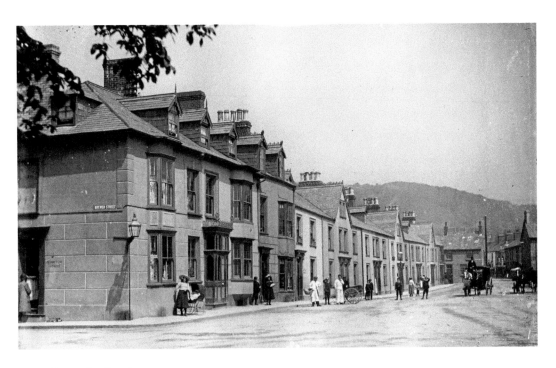

Alexandra Road, *c.* 1900

The houses in this stretch of Alexandra Road are little changed from over a century ago, though prior to the visit of Princess Alexandra the houses were called Railway Terrace. The house with the white porch is named 'Credo' after a sailing ship from Aberystwyth that once carried emigrants to America. The captain lived in the house.

Western Parade, *c.* 1995

Built by the Great Western Railway at the same time as the railway station was improved, Western Parade was a row of small shops that, until their demolition in 1995, was home to a china shop, a Christian bookshop, a coal merchant and a clock repairer. Western Parade was demolished to make way for the Rheidol Retail Park, which also engulfed the former railway goods yard.

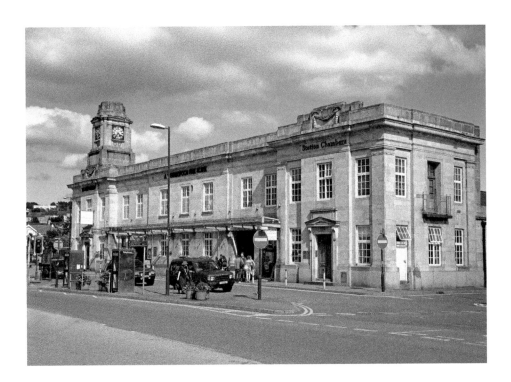

Railway Station, *c.* 1925

In 1922 the Cambrian Railways amalgamated with the Great Western Railway. The following year the new company wasted no time in spending £94,500 on a new and much grander neo-Georgian station. On the first floor was a large assembly room that served as a restaurant. The old station stood directly in front of the new and was demolished on completion of its successor to provide the driveway in the foreground. The building work uncovered a well, possibly the aforementioned chalybeate spring as well as a coin dating back to 290 AD.

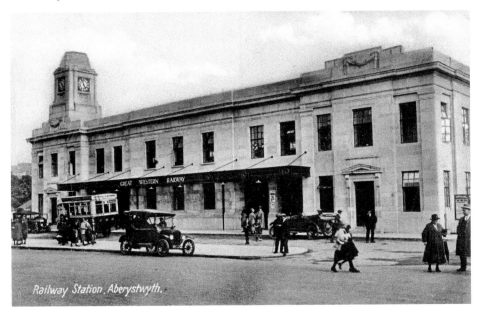

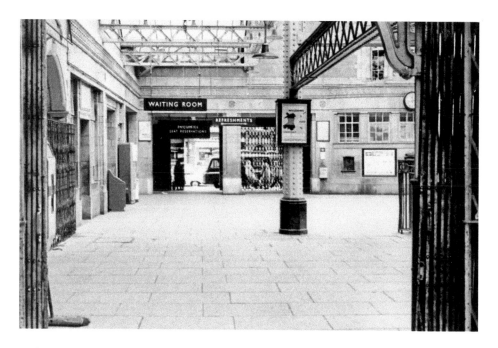

Railway Station Interior, c. 1965

After years of near dereliction, new life was brought to the station in the early years of this century. On the left, where there was once a waiting room, is now 'Shilam,' an Indian Restaurant, whilst the 'Refreshments' sign in the photograph above now points the way to Aberystwyth's newest pub 'Yr Hen Orsaf', which won the 2003 Network Rail Award for "best improvements to, or restoration of, an historic railway or tramway building." Notice that the present day signs are bilingual, not English only as in the 1960s.

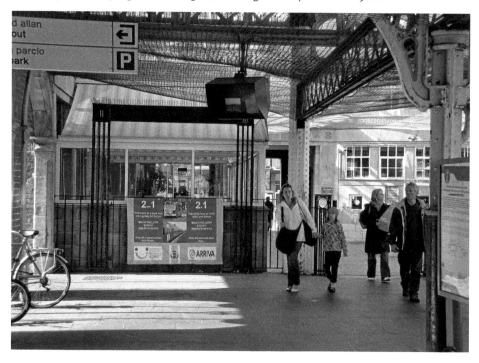

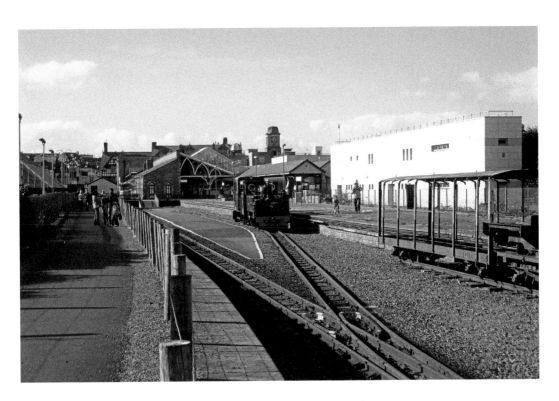

Platforms, Aberystwyth, *c.* 1950

The two platforms nearest the camera were those used by trains on the Aberystwyth-Carmarthen line. It is now the terminus for the Vale of Rheidol narrow gauge railway. Note that the canopies over the other platforms have been removed. On the right in the top photograph can be seen another of Aberystwyth's recent architectural gems.

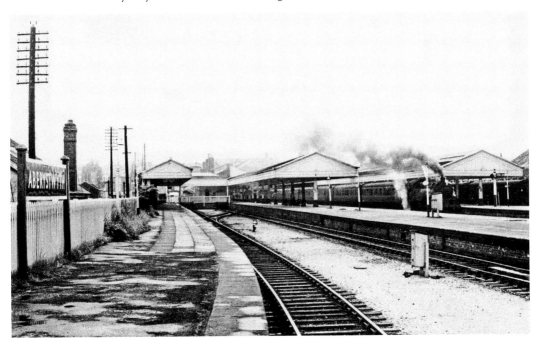

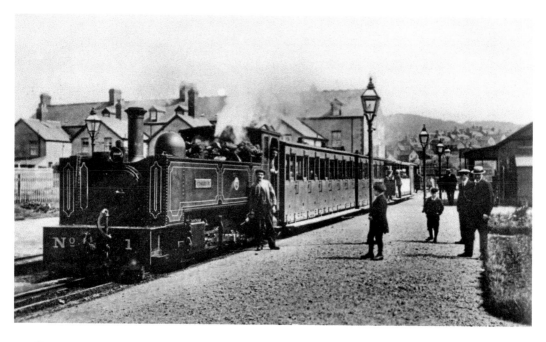

Devil's Bridge Ry, Aberystwyth Station, *c.* 1910

The original terminus for the Vale of Rheidol narrow gauge railway was on the other side of Park Avenue from the Cambrian Railways station. The situation was remedied in 1925 but it was not until 1968 that the track was diverted so as to avoid crossing Park Avenue.

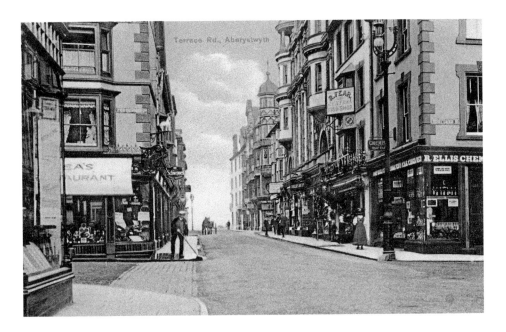

Terrace Road *c.* 1905

A chemist's shop has occupied this corner of Terrace Road for over a century. Boots the Chemist has now occupied the spot for over seventy years. At one time the upstairs included a lending library, remembered as being a disappointing selection of red and green books devoid of their dust-jackets. Across the road is the Varsity Pub, which still retains the name White Horse Hotel over the door, the name that is still used by most locals. Halfway along the street can be seen the newly-built Coliseum Music Hall, later a cinema and now the Ceredigion Museum. Beyond is the turreted Waterloo Hotel, burnt down in 1919.

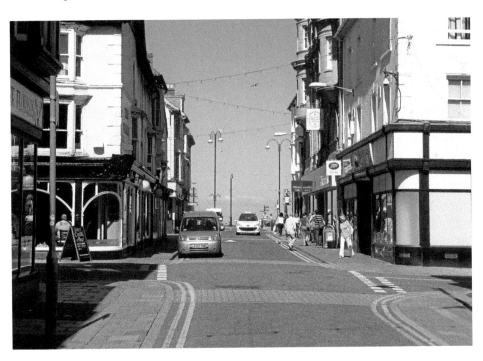

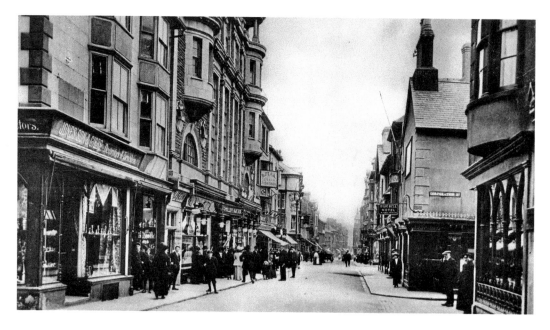

Terrace Road, looking East, c. 1905

What is now the Tourist Information Centre was the premises of Jones, Son & Gibbs, Decorators & Furnishers. Many residents remember it as Astons Furnishings. At the time the top photograph was taken, the building on the extreme right, now the Milk Bar, was a Post Office. Opposite, at the junction with Corporation Street was the Blue Bell Hotel. This was converted into an off licence c. 1980 but is now empty. What was once Phillips Arcade was Peacocks for over half a century, but was until recently Officers Club, a gent's clothes shop.

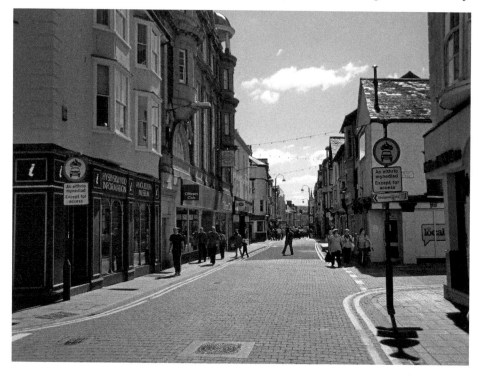

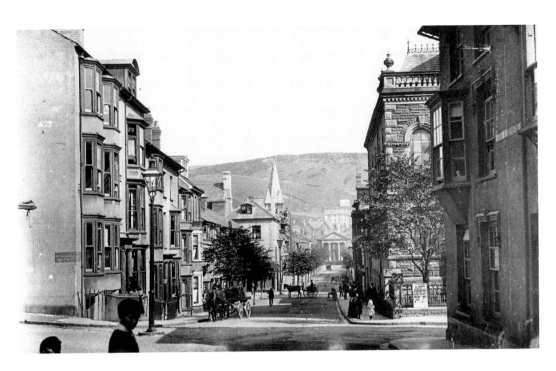

Upper Portland Street *c.* 1905

In the top photograph the centre of the photograph is dominated by the tower of the United Reformed Church. Since the amalgamation with Bath Street Presbyterian Church in 1985 the building has been converted to a doctor's surgery and the tower dismantled. Note the lack of development behind the old town hall, visible in the distance.

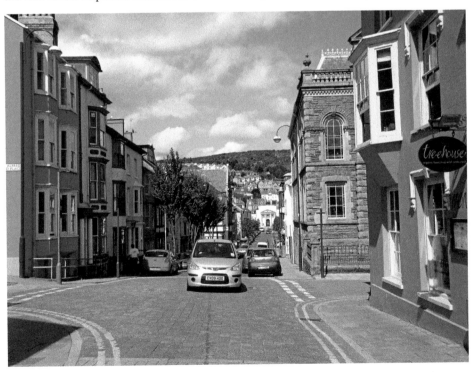

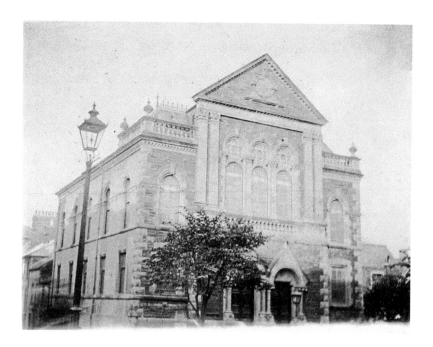

Bethel Welsh Baptist Chapel, *c.* 1910

The present Bethel was built in 1888 on the site of a previous smaller chapel of the same name. A two storey chapel built in Classical Italianate style with a capacity of 750 it was designed by Thomas E. Morgan of Aberystwyth. Just to the right of the chapel is a small cemetery barely noticed by passers-by. The cemetery contains numerous headstones and is a wealth of information about mid nineteenth century Aberystwyth.

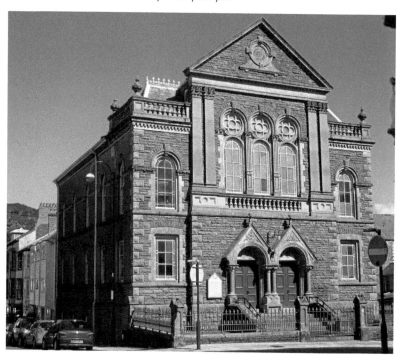

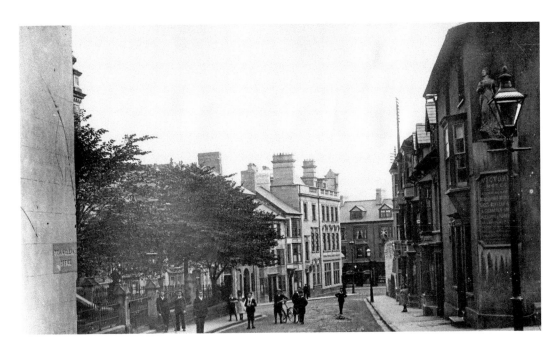

Baker Street, *c.* 1905

On the right of the picture can be seen a ship's figurehead of a young Queen Victoria. Recently restored, the figurehead marked the site of the Victoria Hotel. During the nineteenth century one of the landlords was Matthew Marsh, a veteran of Waterloo and widely believed to be an illegitimate son of King George IV.

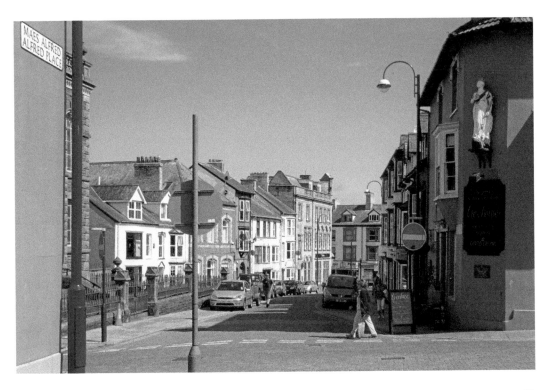

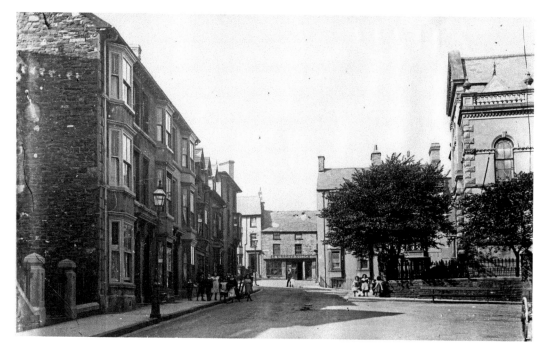

Baker Street & Alfred Place, *c.* 1905

Dominating the centre of the bottom photograph is Aberystwyth Town Library, opened in 1906 and built with the help of a £3,000 grant from the Andrew Carnegie Trust. Previously the site was the premises of I. & G. Lloyd, Coachbuilders. The proposed moving of the library to the Town Hall leaves the building with an uncertain future. Pencaer, the pink-painted house is a Grade II listed building and dates back at least to the early 1830s.

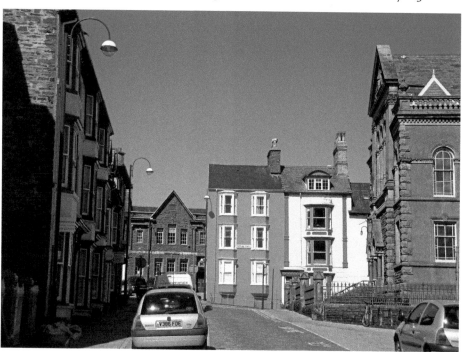

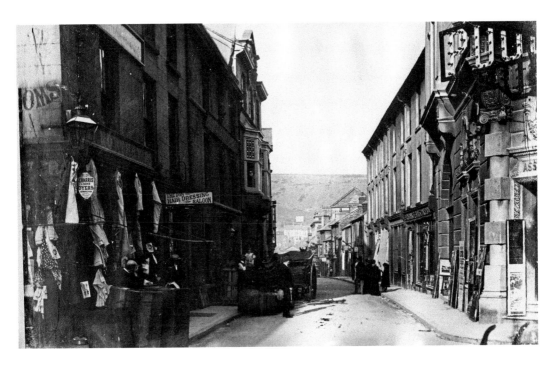

Eastgate, *c.* 1905

The whitewash on the first floor windows of the Conservative Club (on the left) suggest it has only recently been built. Next door, what is now the Court Royale Hotel, was previously the Prince Albert. Across the road was the Palladium Cinema burnt down in 1934.

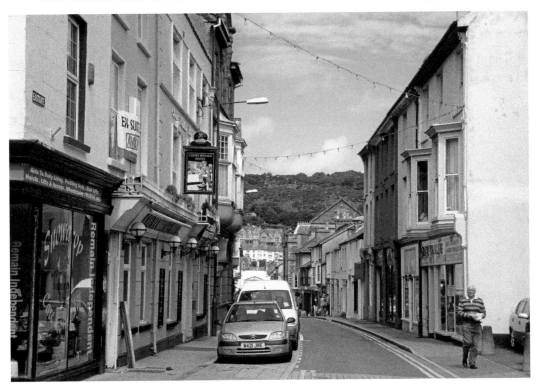

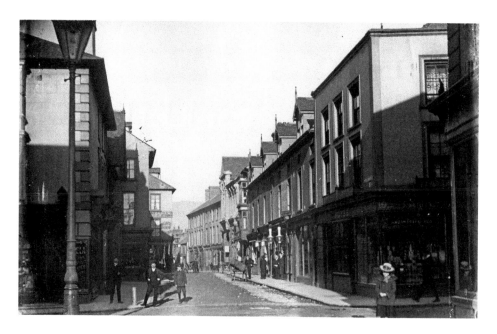

Eastgate, *c.* 1905

At the time the top photograph was taken Eastgate was better known to most inhabitants as Little Darkgate, a throwback to the days when Aberystwyth had town walls. The corner shop on the right hand side was the childhood home of the poet Alfred Noyes from 1884-1898. In the centre of the top photograph can be seen the roof of the Palladium Cinema, victim of a fire in 1934.

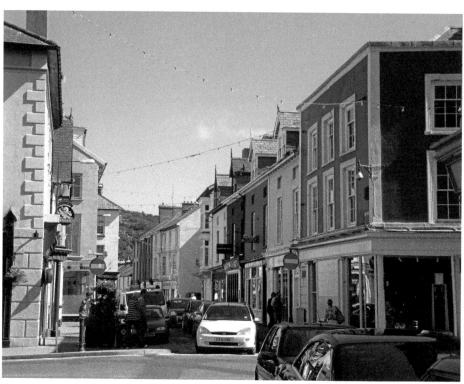

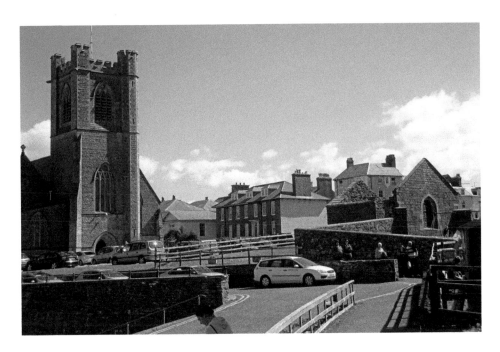

St Michael's Church, *c.* 1885

The St Michael's Church in the bottom view was built in the early 1830s to replace a much smaller whitewashed church on the site. The original idea was that the vestry on the extreme right would eventually be built as a tower. It is now the only surviving vestige of the old church. Being too small and of poor construction the first St Michael's (below) was replaced with the present day St Michaels in 1890 and the old church was razed four years later. Today the vestry houses the neglected gravestone of David Lewis who fought at the Battle of Trafalgar, one of six Aberystwyth men to do so.

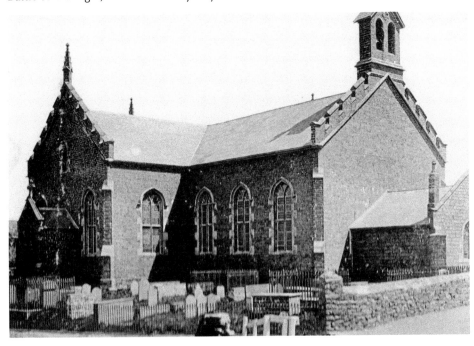

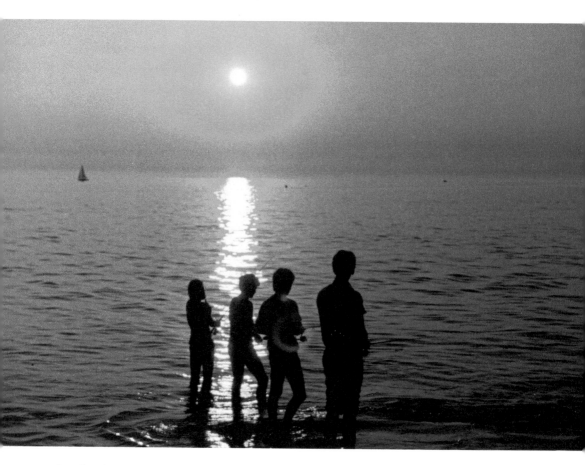

Mackerel Fishing, North Beach, August 1981
Shoals of mackerel start to appear in Cardigan Bay in late June and disappear in September. Mackerel fishing is a rite of passage for Aberystwyth youngsters. Enterprising youngsters, including the author, did very well selling their surplus catch on the prom for 10p each during the mid 1970s.

Acknowledgements

National Library of Wales for kind permission to use images on pages 41,46, 49-51, 53, 54, 66, 67, 71-73,75,81,91-94. Special thanks to Iwan Ap Dafydd, Mark Davey and Michael Jones; Mr T. B. Owen, Aberystwyth for permission to use the images on pages 57 and 64; Chris Forrest & Mark A. Hoofe for permission to use the image on p 65.